POSTCARD HISTORY SERIES

Atlanta
IN *VINTAGE* POSTCARDS
VOLUME *I*

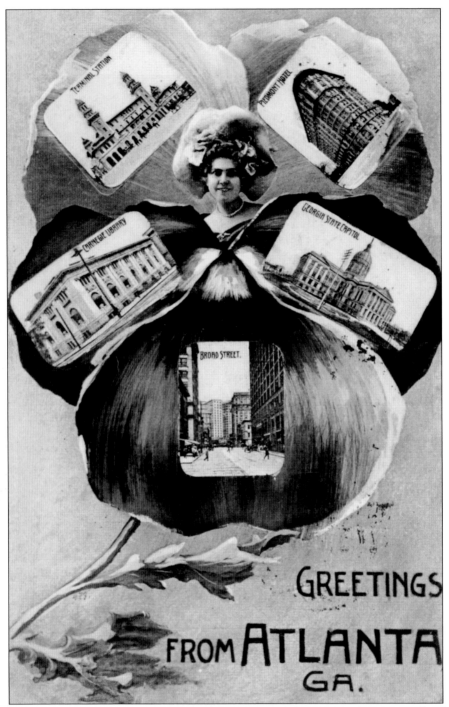

GREETINGS FROM ATLANTA, GA. An unusual greeting card shows a purple pansy with a lovely girl in the center, surrounded by four major buildings of Atlanta: Terminal Station, Piedmont Hotel, Georgia State Capitol, and Carnegie Library. The "Greetings from . . ." postcard was a popular design in 1907, and many cities were represented in this way. (Published by Souvenir Post Card Co., New York; card sent 1909.)

POSTCARD HISTORY SERIES

Atlanta
IN *VINTAGE* POSTCARDS
VOLUME *I*

Elena Irish Zimmerman

ARCADIA
PUBLISHING

Published by Arcadia Publishing
Charleston, South Carolina

Printed in the United States of America

Library of Congress Catalog Card Number: 98-89814

For all general information contact Arcadia Publishing at:
Telephone 843-853-2070
Fax 843-853-0044
E-mail sales@arcadiapublishing.com
For customer service and orders:
Toll-Free 1-888-313-2665

Visit us on the Internet at www.arcadiapublishing.com

*This book is dedicated
to the memory
of my mother and father,
Olga and George H. Irish.*

CONTENTS

ACKNOWLEDGMENTS

I wish to thank several people who helped me produce this book: the Atlanta members of the Georgia Postcard Club, who spoke to me and offered help; Helen Matthews of the Atlanta History Center for her perusal of the files and for sending xerox materials; Franklin M. Garrett, eminent historian, whose cordiality gave me added enthusiasm for the project and whose monumental research already published was the wellspring of my information; Rev. R. David Lancaster of the First Cumberland Presbyterian Church of Knoxville and Conway Gregory of Denton, Maryland, for their insights into denominational history; Tara D. McCrary of Atlanta's Central Congregational United Church of Christ for sending the booklet on the church's history; and R.H. and Richard P. Zimmerman for their careful reading of the text and for their helpful suggestions. Thank you all.

Elena Irish Zimmerman
October 1998

INTRODUCTION

This book will furnish the reader glimpses of Atlanta as it was seen on postcards printed between 1895 and 1940. The images are grouped into categories such as "churches" and "colleges" for easy reference, but beyond the general time span noted above, no precise chronology is attempted.

There are thousands of pictures of Atlanta that denote and illustrate the city's development. The images reside in many albums, archives, and published books devoted to the city's history. One should also recognize the importance of the postcard as a bearer and reflector of history, in addition to its primary purpose as a temporary communicator. From the first U.S. postcards of the 1890s to those of today, senders of these brief messages have wanted to say, "Here's where I am now; I haven't had time to write a letter. Look at this pretty view." The view on the reverse of the card is present history, whether the card was sent in 1900 or 1998. It will reflect "how it was" at the time the card was sent.

Because of the tremendous interest in the postcard after its inception at the Columbian Exposition in Chicago in 1893, photographers all over the world began making pictures of everything imaginable to put onto cards for commercial sale. Practically all the cities of the world are pictured in multiplicity. One can, as a collector, find cards from Alaska to Zambia and all countries and cities in between. Collecting postcards is a major hobby—the third largest in the United States, after stamps and coins.

One can collect views of Atlanta, for instance—as the author has done—or one could specialize only in buildings in Atlanta over 17 stories tall and achieve an admirable group of images. Collectors are able to enjoy unlimited and very specific preferences: babies, dogs, hats, canoes, automobiles, prisons, fashions of 1905, silent movie stars, Shakespeare, Romanian kings, orchids, and so on. The pictures collected document not only the emergence and progression of the items represented but also the prevailing attitudes of the time in which they were sent. A postmark always validates the accuracy of the time.

The author has lived in Atlanta and has collected postcard views of the city for nearly 20 years. She prefers historical or vintage cards showing dates from 1895 to 1940. These images are those of buildings, streets, and activities of which some are long gone. The messages on the cards are of interest, too. These were written by people living their history and sometimes commenting poignant remarks to a business associate, friend, or family member.

Postcards of a city collected with an eye on history become an important panorama of that city's development. They picture diverse places and people and offer implicit comments on the social, ethical, and aesthetic values of the decades past. They illustrate business conditions and

attitudes toward religion, amusements, art, fashion, and humor.

Many developmental aspects of Atlanta are pictured on these cards. There are none that relate directly to the events of the Civil War, for there were no postcards then; however, paintings of various persons and battles have been photographed for use on the cards sent in the early 1900s. The remarkable development of the city in the 1880s and 1890s is reflected in the "new" buildings that arose after the terrible experience of General Sherman's burning of Atlanta. The new emergence of metropolitan Atlanta as a railroad center and commercial giant is well documented. In this book, one will see downtown Atlanta, its churches, hospitals and hotels, colleges, parks, and street scenes.

It is hoped that the reader will enjoy this collection of Atlanta images as much as the author has enjoyed the preparation of it.

Elena Irish Zimmerman
October 1998

One

GREATER ATLANTA

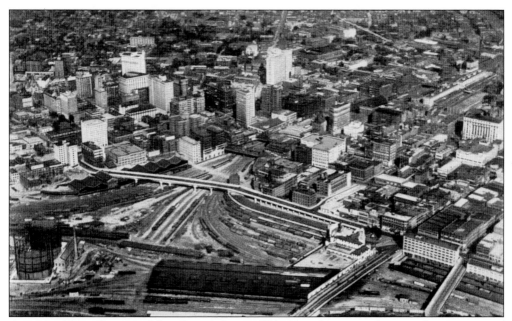

AIRPLANE VIEW, SHOWING NEW SPRING STREET VIADUCT, ATLANTA. A comprehensive view of the city nearly 70 years ago shows several outstanding characteristics of Atlanta. One sees the enormous confluence of railroad tracks, which necessitated several viaducts and bridges as well as one in the center. The downtown area is replete with extraordinary skyscrapers. (Published by Imperial Post Card Co., Atlanta; card sent 1930.)

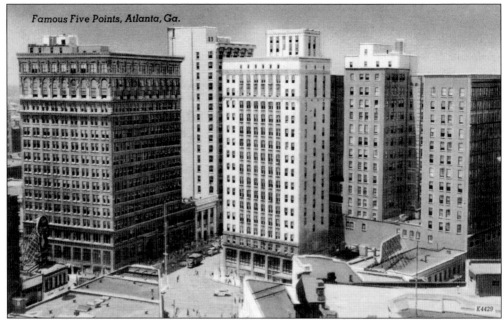

FAMOUS FIVE POINTS, ATLANTA, GA. At the center of downtown Atlanta, a wedge-shaped intersection is formed of Peachtree, Decatur, and Marietta Streets with Edgewood Avenue. From the first settlements here, it has been Atlanta's hub from which principal avenues radiate to all parts of the metropolitan area. (Published by R and R News Co., Atlanta.)

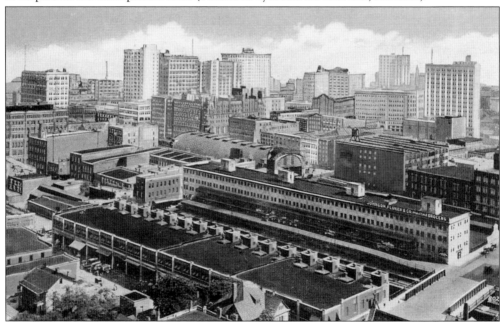

BIRD'S-EYE VIEW FROM TOP OF STATE CAPITOL, SHOWING L&N FREIGHT DEPOT, THE LARGEST CONCRETE BUILDING IN THE WORLD. The size of these railroad buildings emphasizes the importance of Atlanta as a rail center. The building with the rounded roof is the Union Station. At the far end is the Kimball House. (Published by the Chessler Co., Baltimore; card sent 1923.)

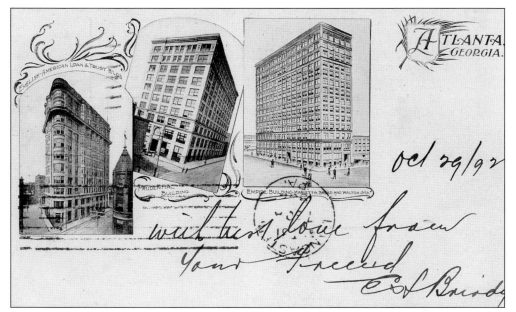

ATLANTA, GEORGIA. A private mailing card illustrates another popular multi-vignette greeting. On postcards sent prior to 1907, only the addressee information was allowed on the stamp side. Messages must be written on the picture side, as we see here. The writer dated his card incorrectly; the postmark on the reverse clearly shows the mailing date of October 29, 1902. (No publishing information; card sent 1902.)

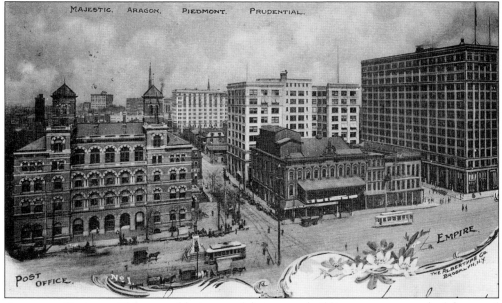

ATLANTA, GEORGIA. This very old picture of downtown buildings names several of them and places them in historical perspective. The post office was erected in 1878, and after 1910, it was used as the Atlanta City Hall. (Published by Albertype Co., Brooklyn, N.Y.; card sent 1906.)

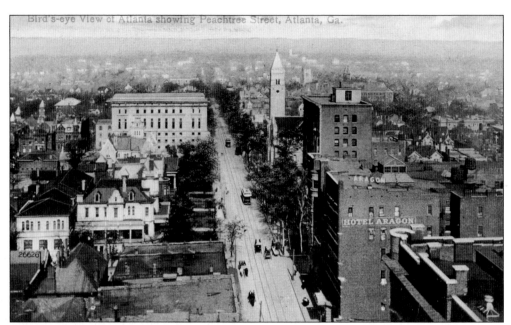

BIRD'S-EYE VIEW OF ATLANTA, SHOWING PEACHTREE STREET. The most famous thoroughfare in Atlanta extends from Five Points northward and has been the address of many historic homes and buildings. In an early view, we see the Aragon Hotel, built in 1892 at the corner of Peachtree and Ellis Streets. At upper center is the tower of the First Baptist Church, built in 1869. (No publication information available.)

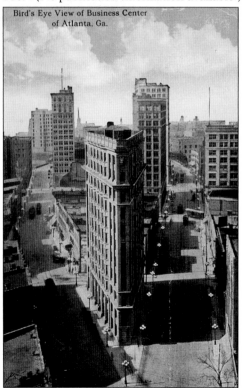

Bird's Eye View of Business Center of Atlanta, Ga.

BIRD'S-EYE VIEW OF BUSINESS CENTER OF ATLANTA. The unusual triangular building in the center, the English-American or Flatiron Building, was erected in 1897 and has become one of the famous landmarks of Atlanta. This is the intersection of Broad and Peachtree Streets at Luckie Street; it is one of several triangular intersections dominating the business district. (Published by I.F. Co., Atlanta; card sent 1916.)

12

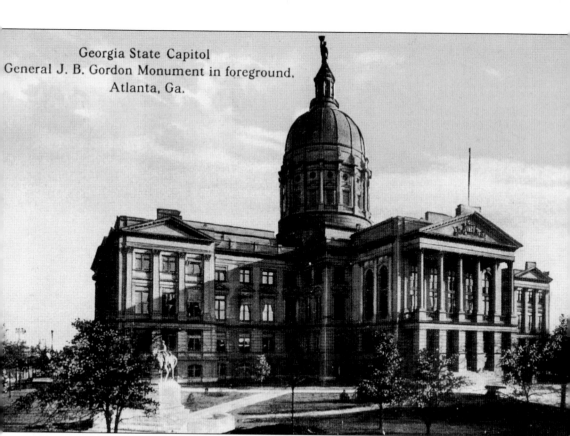

Georgia State Capitol
General J. B. Gordon Monument in foreground,
Atlanta, Ga.

GEORGIA STATE CAPITOL AND GEN. J.B. GORDON MONUMENT. Construction of the Georgia State Capitol began in 1884 and was completed in 1889. It is unique among public buildings in that it cost almost exactly the amount appropriated for it—$1 million. Gold for the dome was donated by citizens of Lumpkin County in 1958. It is located at the intersection of Washington, Mitchell, and Hunter Streets. (Published by I.F.P. Co., Atlanta; card sent 1912.)

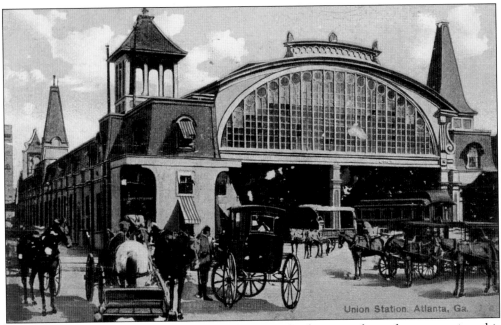

UNION STATION. Before the personal vehicle became the dominant form of transportation, this huge, rounded-roof train station existed on a plot of land called State Square, and was bounded by Pryor, Decatur, Alabama, and Central Streets. It was constructed in 1871. (Published by Witt Bros., Atlanta; card sent 1909.)

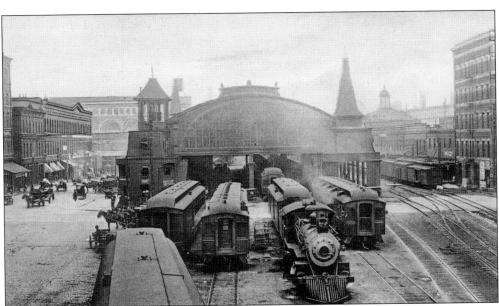

OLD UNION STATION, ATLANTA. Access to cross the tracks in front of the station looks difficult in this view of parked locomotives and passenger cars. The 130-foot-wide station was built of iron, including the roof. One side was occupied by brick offices, and two steeples ornamented each end, with one in the center over the ticket office. (Published by Georgia News Company, Atlanta.)

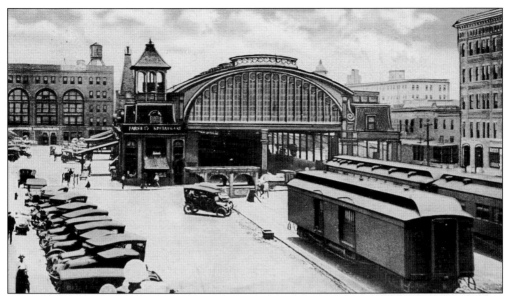

UNION STATION. Traffic conditions remain the same through the decades; only the vehicles change. In this view one sees a restaurant at the left side of the terminal. As railroad traffic became more congested and passengers more numerous, conditions in the station became unbearably inconvenient and confused. By 1930 the station's days were ended and it was demolished. (Published by Tenenbaum Bros., Atlanta; card sent 1920.)

UNION RAILWAY STATION, ATLANTA. Opened in 1930, the new Union Station was approached by pedestrians from Forsyth Street and by vehicular traffic from Spring Street. Its marble-and-limestone exterior and tile roof represented the last word in depot design and construction. Costing $600,000, it contained commodious waiting rooms, a luncheonette, a barber shop, and telegraph connections. The initial train into the new station was drawn by a new $100,000 locomotive especially prepared for the occasion. (Published by R and R Magazine Agency, Atlanta.)

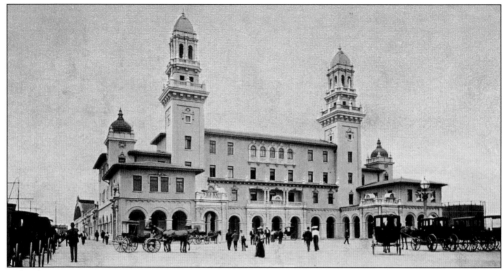

ATLANTA TERMINAL STATION. In 1904, several companies, including the Southern Railway, built the Terminal Station at Mitchell Street and Madison Avenue (Spring Street). It opened May 13, 1905. The employees were dressed in green uniforms with white caps. Thousands of Atlantans visited the new building during the day. (Published by Raphael Tuck and Sons, London; card sent 1907.)

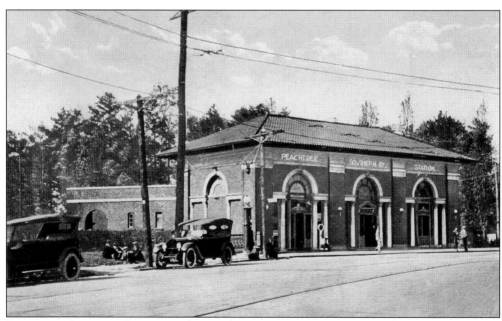

PEACHTREE STATION, ATLANTA. This auxiliary passenger station was established by Southern Railway in 1918 for the convenience of travelers in north Atlanta. The station was located at Brookwood Drive and Peachtree Street. By 1940, Atlanta's two major railway stations were serving 15 main lines of 8 major railway systems, running 110 passenger trains in and out of the city daily. (Published by Imperial Post Card Co., Atlanta.)

COURT HOUSE, ATLANTA. The Fulton County Court House was built in 1882 at a cost of $100,000, on the corner of Pryor and Hunter Streets, site of the present courthouse. In 1897, it was purchased for use as a city hall and served until it was demolished in 1911. (Published by Souvenir Post Card Co., New York.)

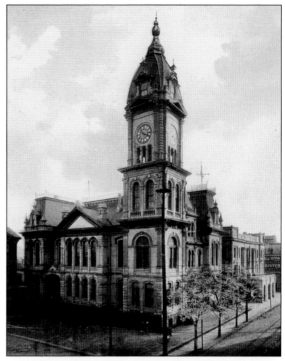

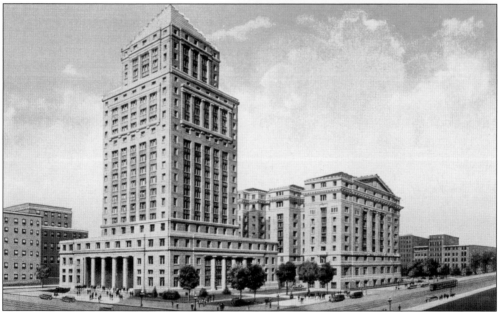

FULTON COUNTY COURT HOUSE AND NEW CITY HALL, FACING SOUTH PRYOR, EAST HUNTER, AND CENTRAL AVENUE. The new courthouse (right) was completed in 1914 at a cost of $1,300,000. Made of granite in a classic design, it has a pediment on each side and Corinthian columns on the facade. The city hall (left), 15 stories high and semi-Gothic in design, was completed in 1930. The construction utilized Georgia products such as granite, marble, brick, and terra cotta. The architect for both buildings was Ten Eyck Brown. (Published by Imperial Post Card Co., Atlanta.)

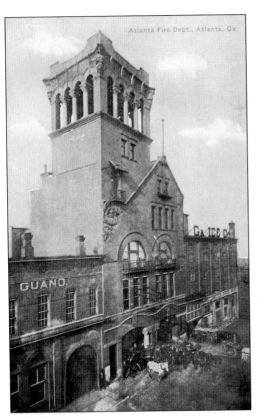

ATLANTA FIRE DEPARTMENT. Built in 1892, the new fire department headquarters on West Alabama Street replaced the old one of South Broad Street. The bell from the old building was installed in the new but later was removed to Grant Park. Here, the firemen are seen with their horse-drawn equipment. (No publication information available.)

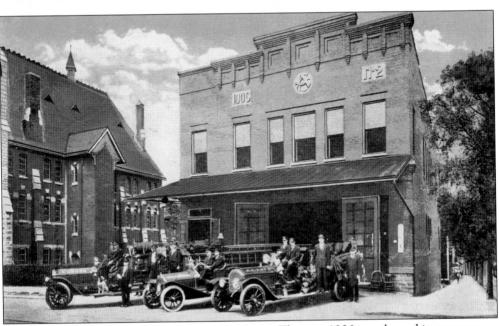

WASHINGTON STREET FIRE DEPARTMENT, ATLANTA. The year 1906 is embossed in concrete on the facade of this building. The vehicles are handsome and indicate a much later date than that of the building. (Published by I.P.C. Company, Atlanta; card sent 1921.)

POLICE STATION, ATLANTA.
"Atlanta's finest" are pictured here, in front of their impressive building at 175 Decatur Street. On opening day, March 25, 1893, there was a parade beginning at the old headquarters on Pryor Street, led by Chief Connolly and a drummer. Following were mounted policemen, then officers on foot, marching four abreast. The detective squad and newspaper reporters brought up the rear in patrol wagons. (No publishing information available; card sent 1908.)

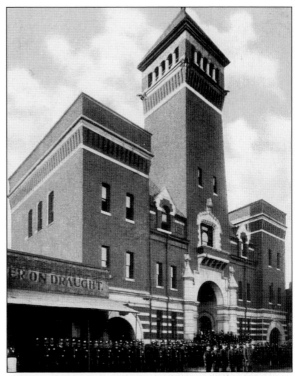

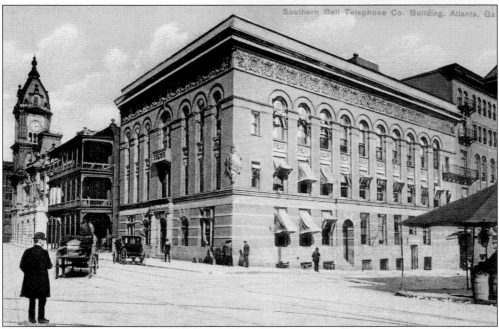

SOUTHERN BELL TELEPHONE CO. BUILDING, ATLANTA. Southern Bell came to Atlanta in 1877 and opened the city's first switchboard in 1881. The building in the picture, located at 78 South Pryor Street at Mitchell, prevailed until the early 1930s when it was bought by Fulton County to add to its courthouse property. The old courthouse (demolished in 1911) may be seen at extreme left. (Published by Georgia News Co., Atlanta.)

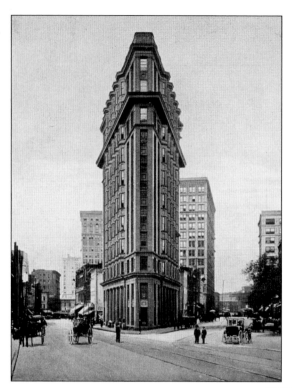

THE ENGLISH-AMERICAN BUILDING. Otherwise known as the Flatiron Building, this landmark structure is located at the intersection of Broad, Peachtree, and Luckie Streets in the heart of the city. Built in 1897, it is 11 stories tall and was designed by Bradford Gilbert of New York for the English-American Loan and Trust Company. On the sides of the building facing Peachtree and Broad Streets, one sees bay windows and Ionic pilasters incorporated into the design. The building was sold to Hamilton Bank in 1974 and has undergone extensive renovation. (Published by Raphael Tuck and Sons, London.)

THE HURT BUILDING. Constructed in 1913 at Edgewood Avenue and Exchange Place, the Hurt Building commemorates Joel Hurt (1850–1926), one of Atlanta's pioneer entrepreneurs of civic betterment. His substantial projects include the Atlanta Home Insurance Company, the East Atlanta Land Company, and the building of Inman Park through his establishment of the first electric streetcars in the city. In 1908, he sold 1,500 acres of his landscaped properties to initiate the development of Druid Hills. The Hurt Building, extended in 1927, became the largest office building in the South. (Published by I.F. Co., Atlanta.)

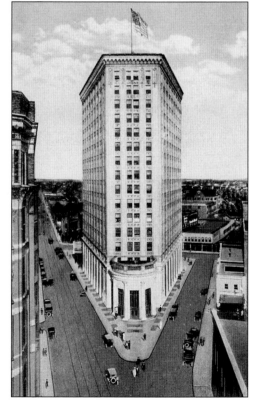

TEMPLE COURT, ATLANTA. Built in 1884 at Alabama and Pryor Streets, this building housed the Gate City National Bank until 1893, when the bank went out of business. In 1896, four stories were added, and the structure became known as Temple Court. (Published by Georgia News Co., Atlanta.)

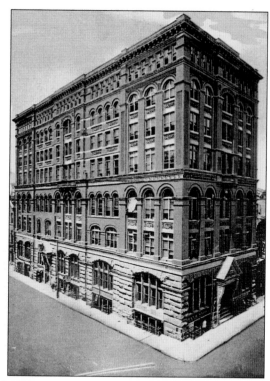

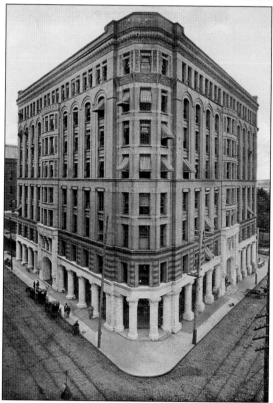

EQUITABLE BUILDING, ATLANTA. Built in 1892 by the East Atlanta Land Company, headed by Joel Hurt, this eight-story office building was the first modern structure of its kind. It was designed by Burnham and Root of Chicago. In 1913, it became the Trust Company of Georgia Building; it was demolished in 1971. (Published by Souvenir Post Card Co., New York.)

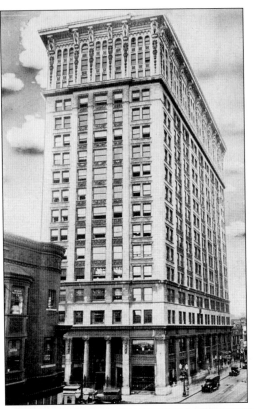

THE CANDLER BUILDING. At the corner of Peachtree and Hunter Streets, this 17-story building was dedicated on January 4, 1906. It was financed by Asa G. Candler with money from his Coca-cola enterprises. "As tall as the Candler Building" was for years the way to compare new Atlanta skyscrapers. The building is constructed of Georgia marble and terra cotta; a number of carved panels illustrate the liberal arts and sciences. It presently houses the First Georgia Bank and numerous professional offices. (Published by Sugarman-Hirsch Co., Atlanta; card sent 1937.)

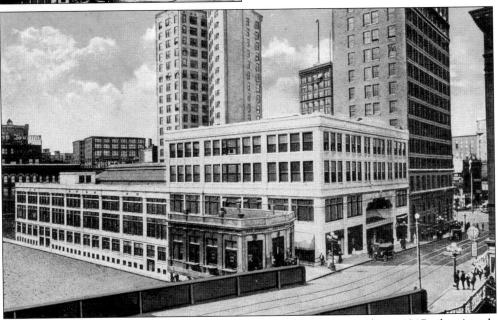

PEACHTREE ARCADE, PEACHTREE AND NORTH BROAD STREETS. Built in 1917, the Arcade occupied land fronting on Peachtree and running west along the railroad right-of-way to Broad Street. Erected by Flynn Realty Company, the unique structure was the only one of its kind in Atlanta. (Published by the Imperial Post Card Co., Atlanta; card sent 1927.)

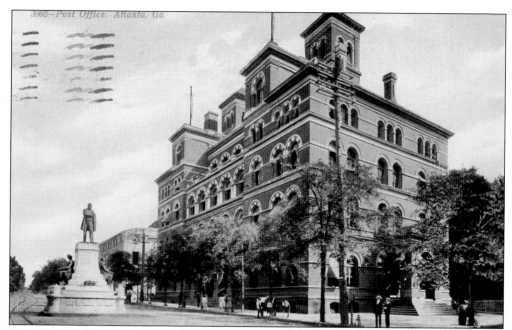

POST OFFICE, ATLANTA. The Atlanta Post Office and Custom House was built in 1878 under the supervision of Thomas G. Healey. When the subsequent post office building on Forsyth Street was completed, this building became the Atlanta City Hall and was so used until 1930, when it was demolished. One building wrecker went broke trying to tear it down. It was a solid structure. (Published by Adolph Selig Co., St. Louis-Leipzig-Berlin; card sent 1908.)

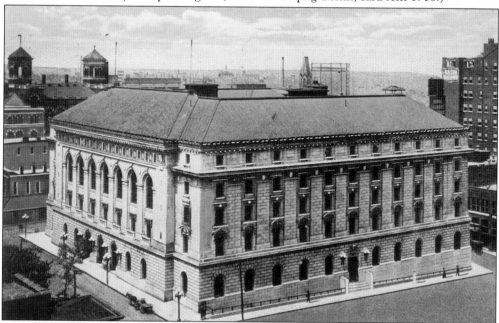

POST OFFICE, ATLANTA. The "new" post office was built in 1911 at a cost of $1 million. Located at 56 Forsyth Street at Walton, it is a four-story, classical landmark made of granite quarried at Stone Mountain. Until 1975, it housed both post office personnel and the Federal courts; now it contains only the courts. (Published by I.F. Co., Atlanta; card sent 1917.)

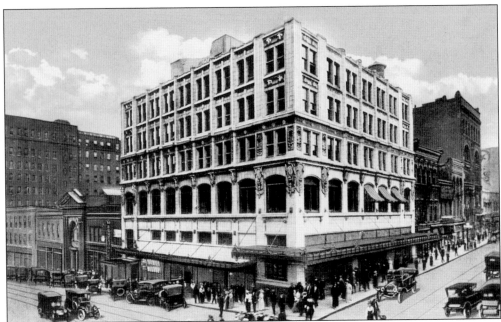

CONNALLY BUILDING. Located at 9 East Alabama Street at Whitehall, the Connally Building commemorates its founder, Dr. Elijah Lewis Connally (1837–1930), a distinguished Atlanta physician and businessman. Dr. Connally was one of a large family of pioneer settlers of southwest Fulton County. Between 1887 and 1930, his family lived at the famous "Homestead," which was Confederate Gen. John B. Hood's headquarters prior to Sherman's occupation of Atlanta. (Published by I.F. Co., Atlanta.)

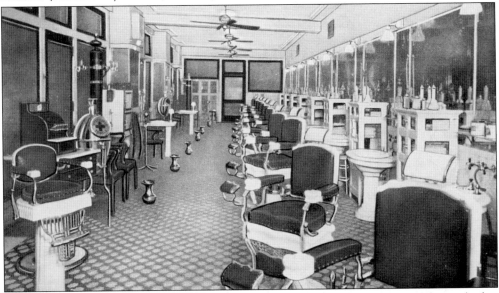

CONNALLY BUILDING BARBER SHOP. A well-equipped "tonsorial parlor" is seen here—barber chairs, including a child's seat (left); manicure tables (background center), and a number of brass spittoons. The advertising on the reverse side of the card assures us that this is "the finest, most sanitary, and up-to-date place of its kind in the South," and states that customers will receive "polite and efficient service." (Published by I.F. Co., Atlanta.)

THE HEALEY BUILDING. Completed in 1913 at Forsyth and Walton Streets, the Gothic-style, 18-story Healey Building bears the name of a prestigious Atlanta family of builders. Thomas G. Healey (1818–1897) came to Atlanta in 1852 and began a building career of mammoth proportions. His own Healey Building appeared in 1877 at Five Points; it was demolished in 1930, however, to make way for the William-Oliver Building. He built the Church of the Immaculate Conception, First Presbyterian, Second Baptist, Trinity Methodist, and the old Atlanta Post Office and Custom House. His son, William T. (d. 1920) built the present Healey Building; his grandsons William T. and Oliver M. built the William-Oliver Building. (Published by E.C. Kropp Co., Milwaukee.)

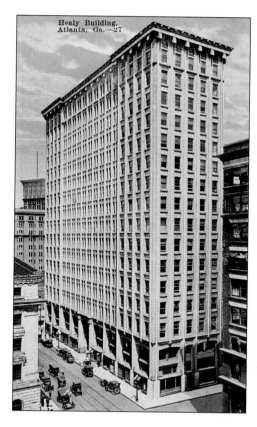

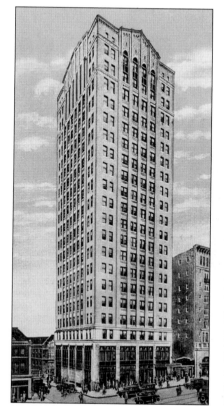

RHODES-HAVERTY BUILDING. "Atlanta's newest and tallest skyscraper" of 21 stories was completed in 1929 at Peachtree and Williams Streets. It was designed by local architects Pringle and Smith and cost $1,600,000. It was named for J.J. Haverty and A.G. Rhodes, officers of the investment company bearing their names. The reverse side of the card informs us that "1,234 streetcars pass its door daily." (Published by Imperial Post Card Co., Atlanta; card sent 1932.)

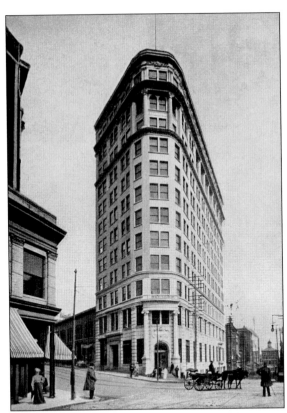

THE CENTURY BUILDING. Located at the northwest corner of Whitehall and Alabama Streets, the Century Building was constructed in 1903. Because the Atlanta National Bank was housed here, the building took on the name of the bank. (Published by Raphael Tuck and Sons, London; card sent 1908.)

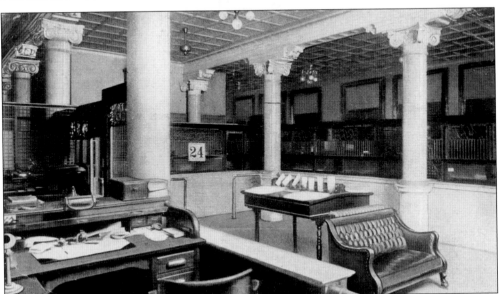

INTERIOR VIEW OF BANKING ROOM, AMERICAN NATIONAL BANK, ATLANTA. In 1916, the American National Bank merged with the Atlanta National. The location of this banking room is uncertain; however, it is certainly reminiscent of such rooms in 1908. The telephone, roll-top desk, and couch are typical furnishings. (No publishing information available; card sent 1908.)

THIRD NATIONAL BANK, ATLANTA. This bank and its near neighbor, the Fourth, illustrate the banking boom that took place in Atlanta in the early 1900s. Located at Broad and Alabama Streets, the bank opened January 15, 1896. After a sojourn in the Empire Building in 1901, it erected its own building at Broad and Marietta Streets and is now the Atlanta Federal Savings and Loan Building. (Published by Tenenbaum Bros., Atlanta.)

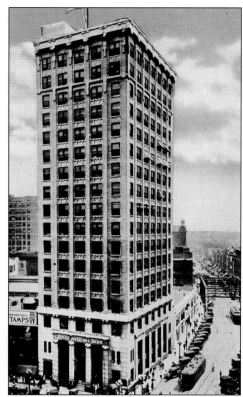

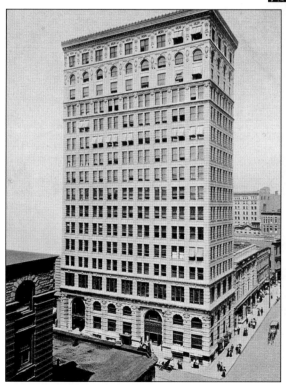

FOURTH NATIONAL BANK. A 16-story, palatial structure of Italian Renaissance design, the Fourth National Bank opened January 1, 1905, at Peachtree and Marietta Streets. Through a series of bank mergers, including Atlanta National, Lowry National, and Fourth National, "the most powerful financial institution south of Philadelphia" emerged in 1929 as the the First National Bank. (Published by Raphael Tuck and Sons, London.)

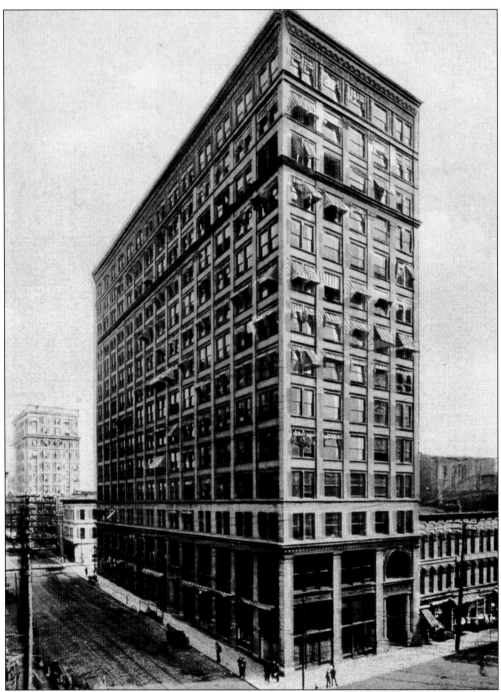

THE EMPIRE BUILDING. Erected in 1901 at the intersection of Broad, Marietta, and Walton Streets, the Empire Building was characterized by its numerous windows and relative lack of ornamentation. Known later as the Atlanta Trust Company Building, it was sold to C&S Bank in 1929. Extensive remodeling took place, and when it reopened December 1, 1931, the C&S Building revealed arched and pedimented lower windows outlined with hewn masonry blocks, and large-scaled doorways. (Published by Adolph Selig Co., St. Louis-Leipzig-Berlin.)

CHAMBER OF COMMERCE. The Atlanta Chamber of Commerce was organized in 1871 and first occupied the building at 44 East Alabama Street. On January 16, 1885, it moved to its own building at Pryor and Hunter Streets, as seen here. The building was demolished in 1941. Street vehicles verify the early date of this picture, as does the postmark. (Published by Georgia News Co., Atlanta; card sent 1910.)

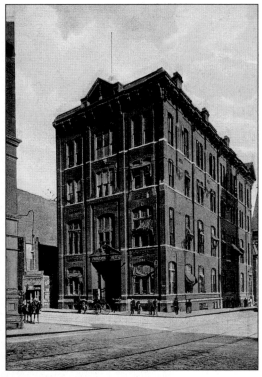

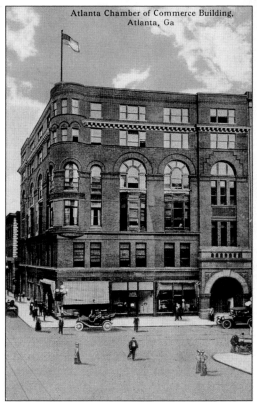

Atlanta Chamber of Commerce Building,
Atlanta, Ga

ATLANTA CHAMBER OF COMMERCE BUILDING. After moving from its home to temporary quarters in the Empire Building in 1907, the Atlanta Chamber of Commerce purchased the former YMCA Building at Pryor and Auburn Streets in 1912 and occupied these offices until 1948, when it moved again to the Volunteer Building. (Published by I.F. Co., Atlanta.)

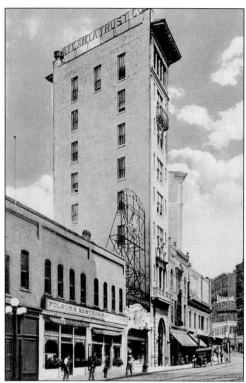

ATLANTA TRUST BUILDING. This unusually narrow building at 140 Peachtree Street stood in the heart of downtown. Architects Hentz, Reid, and Adler produced it in 1910. Originally known as the Hillyer Trust, it later housed the Citizens' and Southern National Bank's Peachtree office. (Published by I.F. Co., Atlanta.)

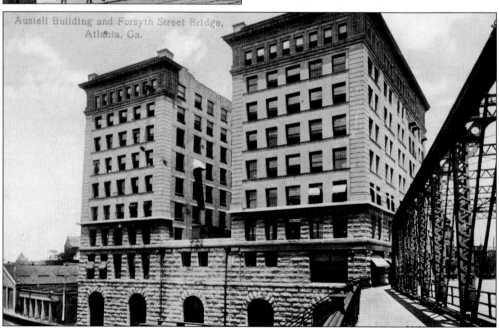

AUSTELL BUILDING AND FORSYTH STREET BRIDGE. Among the important office buildings erected in Atlanta in 1896, the Austell Building was "particularly large, substantial, and elegant." Nine stories high, it was located near the railroad tracks, beside the Forsyth Street Bridge, which preceded the Austell in 1891. The old Atlanta Journal Building, now demolished, was just across the street. (No publishing information available; card sent 1911.)

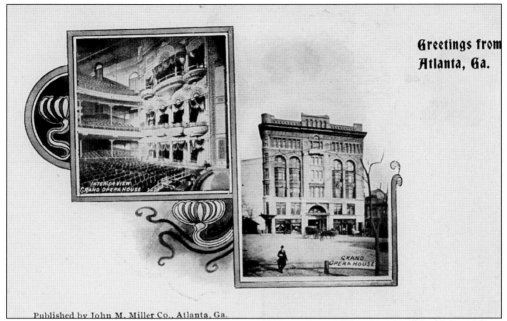

Greetings from
Atlanta, Ga.

Published by John M. Miller Co., Atlanta, Ga.

GREETINGS FROM ATLANTA, GEORGIA. This very early "greeting" postcard (c. 1905) shows two views of the splendid DeGive Opera House. This was the second theatre built by Laurent DeGive, whose first house endured from 1870 to 1893. Many world-class actors performed here, including Sarah Berhardt, Joseph Jefferson, and Edwin Booth. The opening night of the new Grand on February 10, 1893, was one of the most brilliant society events of the decade. The *Atlanta Constitution* reported that "the house was packed from pit to dome." The play was *Men and Women*, written by Belasco and deMille. (Published by John M. Miller Co., Atlanta.)

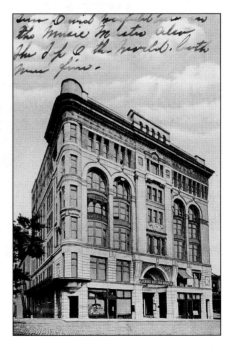

GRAND OPERA HOUSE. The sender of this card has written on the front: "Saw David Warfield here in *The Music Master*, also *The Top of the World*. Both were fine." The Grand, located at 157 Peachtree Street, was later known as Loew's Grand and was the center of Atlanta's theatre-going for decades, offering everything from Shakespeare to political assemblies. It accommodated 2,700 patrons and was the first Atlanta theatre to use electric lights. In 1939, renovated and modernized, it hosted the premiere of *Gone with the Wind*. It was destroyed by fire January 31, 1978. (Published by F. von Bardoleben, New York; card sent 1909.)

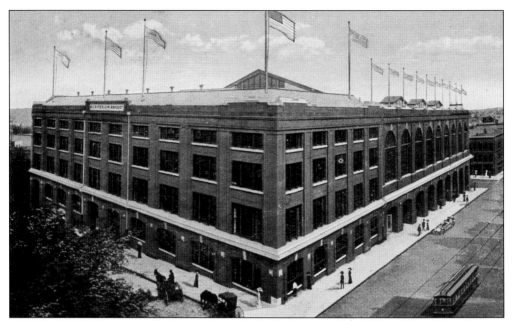

AUDITORIUM, ATLANTA. The Atlanta Civic Auditorium, at Courtland and Gilmer Streets, opened January 15, 1909, after two years of planning and at a cost of $190,000. Information on the reverse side of the card maintains that the facility is "the most complete municipal auditorium in the South" and that "the acoustics are perfect." (Published by I.F. Co., Atlanta.)

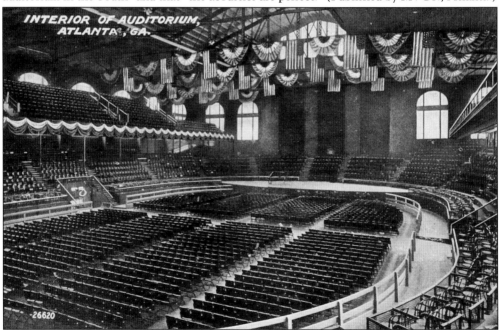

INTERIOR OF AUDITORIUM, ATLANTA. Possibly in preparation for some celebration, flags lend a festive atmosphere to the 8,000-seat auditorium. The elliptical arena is 150 feet long and 90 feet wide, surrounded by boxes, a dress circle, and balconies. At the east end is a $50,000 organ. The building also includes a smaller convention hall. (No publication information available; card sent 1910.)

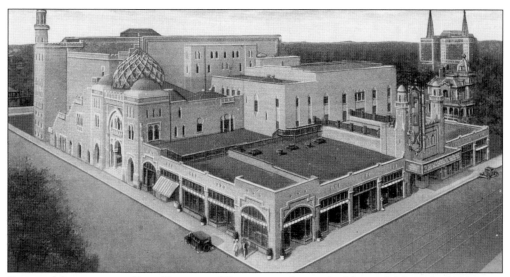

SHRINE MOSQUE AND FOX THEATER. This extraordinary building of Moorish design was conceived as the headquarters of the Yaarab Temple of the Mystic Shrine. Financial difficulties prompted the Shriners to ally with William K. Fox, the movie magnate, whose $3 million allowed its construction and turned it into a theater of great beauty. It opened December 25, 1929, showing a feature film and a Mickey Mouse cartoon, preceded by Enrico Leide conducting the Fox orchestra, a Fanchon and Marco stage review, organist Iris Wilkins, and Fox Movietone News. (Published by Imperial Post Card Co., Atlanta.)

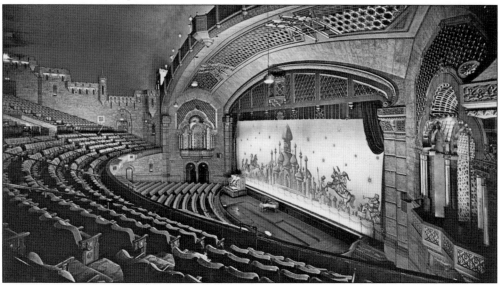

INTERIOR, FOX THEATER. The Fox interior is replete with Egyptian and Moorish motifs. The audience is seated in what seems to be a palace courtyard with the blue night sky above sparkling with stars and with clouds moving across it. The sides seem to be castellated walls with dimly lit barred windows and minarets. The fantasy is carried through all the rooms, lounges, stairways, and entrances, which are fully and beautifully detailed. The Fox went through some dark days; however, its mortgage was paid in 1978 and a determined Atlanta citizenry has restored it to its eminence as one of the country's outstanding theaters. (Published by Floyd J. Kile, Atlanta.)

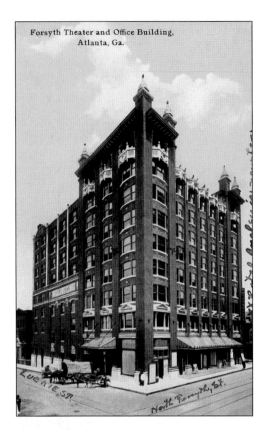

Forsyth Theater and Office Building,
Atlanta, Ga.

FORSYTH THEATER AND OFFICE BUILDING.
This early picture was taken between 1911,
when the Forsyth Theater was constructed,
and 1914, when the Ansley Hotel was built.
The sender gives us the location in his own
writing—Luckie and Forsyth Streets—and
news that the Ansley Hotel now occupies
the lot next door. The sender has also
marked the location of his office on the fifth
floor. The new post office was one block
away. (Published by I.F.P. Co., Atlanta; card
sent 1914.)

HOWARD THEATER. Just north of DeGive's
Grand, the Howard Theater presented "one
of the handsomest facades ever to grace
Peachtree Street." Built by George Troup
Howard in 1920, it was designed by Hentz,
Reid, and Adler. Described variously as
"palatial" and "most beautiful in the
country," it was primarily a movie house that
endured until it was torn down in 1960. For
years, it featured Enrico Leide conducting the
Howard orchestra in elaborate prologues and
overtures. (Published by Imperial Post Card
Co., Atlanta.)

ALAMO THEATRE, 30 WHITEHALL STREET. This small theatre presents an intriguing facade of Moorish design. Unfortunately, the card furnishes no postmark or other information; it was made as a private postcard and very likely had limited edition. If we could identify the actresses on the two medallions, we would know much more. (No publishing information available; real photo.)

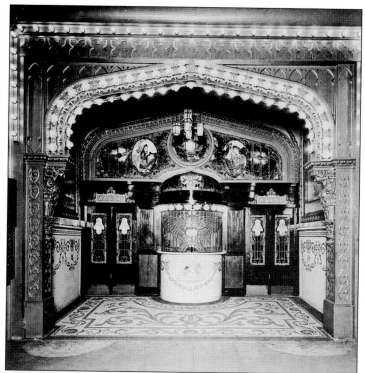

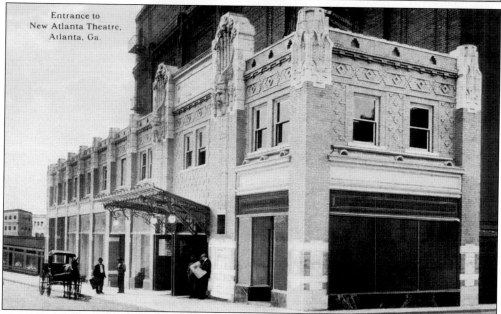

Entrance to New Atlanta Theatre, Atlanta, Ga.

ENTRANCE TO NEW ATLANTA THEATRE. Built in 1911 at Exchange Place and Edgewood Avenue, opposite the Hurt Building, the Atlanta Theatre became the leading outlet for the legitimate stage in Atlanta. Almost every theatrical celebrity of the day appeared here, well into the 1920s. In addition to road shows of New York plays, several stock companies performed throughout the year, and there were summer sessions of light opera as well. (Published by I. F. P. Co., Atlanta; card sent 1912.)

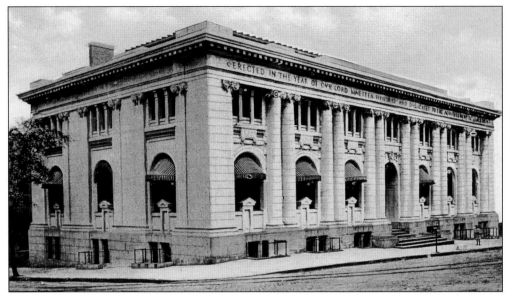

CARNEGIE LIBRARY. Organization of the Carnegie Library began in 1899 with a gift of $145,000 from steel magnate Andrew Carnegie. Constructed of white Georgia marble in Ionic design, it shows names of famous writers carved on the facade above the second-floor windows. It opened March 3, 1902, at 126 Carnegie Way. After a building program of expansion and modernization in 1950, the building served as the nucleus of the large and modern plant known as the Atlanta Public Library. (Published by S. H. Kress & Co.)

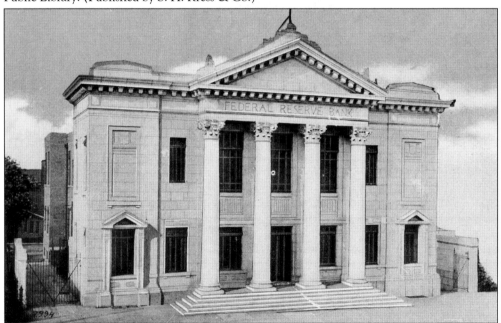

FEDERAL RESERVE BANK. This building opened on October 1, 1918, on the site of the historic First Presbyterian Church, which had been demolished two years earlier. Located at 95 Marietta Street, in the heart of the city, it was designed by Ten Eyck Brown in classic Greek style and cost $100,000. It was enlarged in 1920 and again in 1922. (Published by Chessler Co., Baltimore.)

Two

CHURCHES

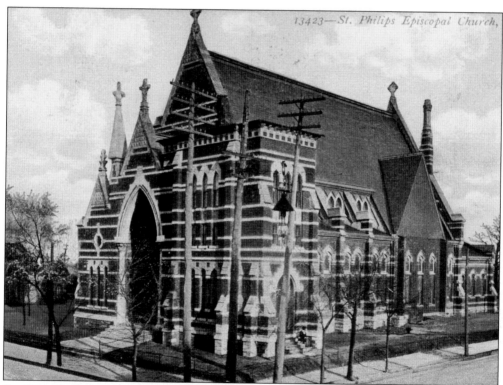

13423—*St. Philips Episcopal Church,*

ST. PHILIP'S EPISCOPAL CHURCH. Located at the corner of Washington and Hunter Streets, St. Philip's Episcopal Cathedral was erected in 1881. An Atlanta reporter commented that the building was "a new departure in architecture in the direction of cultivated artistic taste" and that the windows were "a beautiful combination of graceful form and usefulness." The first services took place October 15, 1882. The church was demolished in 1936; a state office building now occupies the site. (Published by Souvenir Post Card Co., New York.)

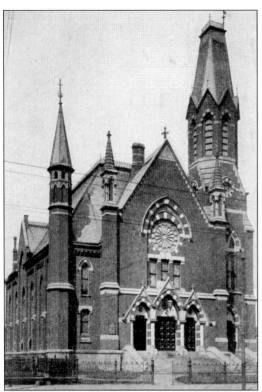

First Presbyterian Church. The Presbyterians in Atlanta first organized in 1848 and built their first church on Marietta Street in 1852. A more ornate and spacious building (pictured here) replaced the older one on the same site in 1878. It was demolished in 1916. (No publication information; card sent 1909.)

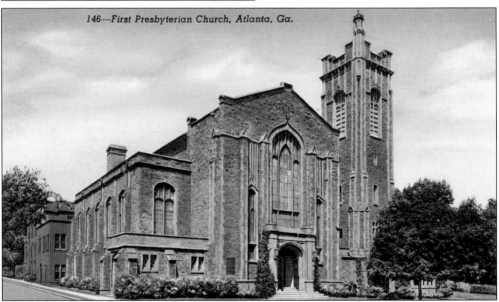

146—First Presbyterian Church, Atlanta, Ga.

First Presbyterian Church. The "new" First Presbyterian, started in 1915 at Peachtree and Sixteenth Streets, was dedicated April 6, 1919. Special features of its construction include the beautiful stained-glass windows celebrating the history of Christianity, which were executed by Tiffany of New York and D'Ascenzo of Philadelphia. In 1922, radio station WSB began broadcasting the Sunday services, the first such broadcasts in the South. In 1929 and 1930, the tower and carillon of bells were added. (Published by R an R News Co., Atlanta.)

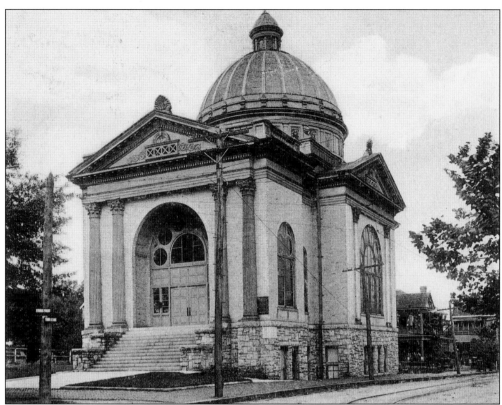

CUMBERLAND PRESBYTERIAN CHURCH. Cumberland Presbyterians have been in Georgia since 1843, though few churches were organized. In 1906, this imposing edifice was constructed at the corner of Spring and Harris Streets. Many Cumberlanders merged with the Presbyterian Church U.S.A. in 1906, and until 1958, there were no Cumberland Presbyterian congregations in the Atlanta area. (No publishing information available; card sent 1918.)

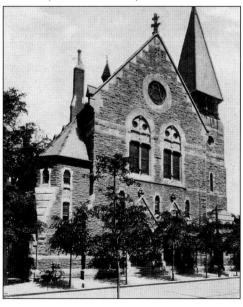

CENTRAL PRESBYTERIAN CHURCH. The original Central Presbyterian Church was built in 1860 at 201 Washington Street. It was replaced in 1885 by this modified Gothic structure of cream brick and natural stone. The bell, which had hung in the belfry of the old building, was transferred to the new, despite the fact that it was mute; it was cracked by the vigor of a bell ringer in 1864 when he announced the approach of the Federal Army. (No publication information available; card sent 1910.)

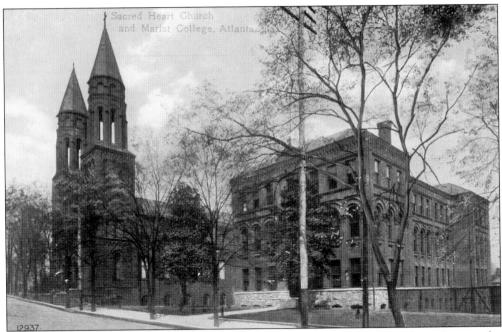

SACRED HEART CHURCH AND MARIST COLLEGE. Located at Peachtree and Ivy Streets, the graceful spires of Sacred Heart Church have been an Atlanta landmark since 1898. Designed by Walter T. Downing, the church is constructed of red brick and terra cotta in the Romanesque style. Stained-glass windows were added between 1902 and 1905. Marist fathers are in charge of the church. (Published by I.F. Co., Atlanta; card sent 1912.)

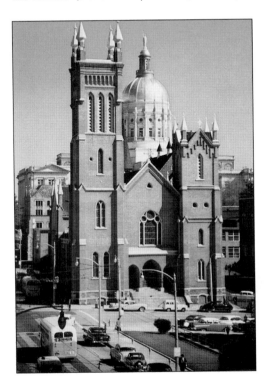

CHURCH OF THE IMMACULATE CONCEPTION. The oldest church in Atlanta, having existed on this site before the Civil War, Immaculate Conception Shrine survived the Battle of Atlanta but was razed and rebuilt in 1869. Located at 48 Hunter Street at Central, this red brick, Gothic church has seen all of Atlanta build up around it. It was designated a Diocesan Shrine in 1954 and was renovated in 1969. The postcard shows its proximity to the State Capitol. (No publishing information available.)

St. Mark Methodist Church. Completed in 1903, St. Mark Methodist is a gray granite, Gothic structure at the corner of 781 Peachtree Street and Fifth Street. It has a triple-arched facade, a belfry, and outstanding stained-glass windows designed by Franz Mayer and Russell Church. The reverse side of the card informs us that this is one of the largest Methodist churches in Georgia. (Published by Curt Teich Co., Chicago; card sent 1945.)

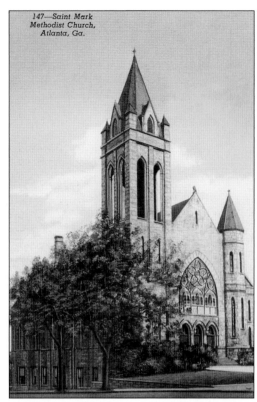

147—Saint Mark Methodist Church, Atlanta, Ga.

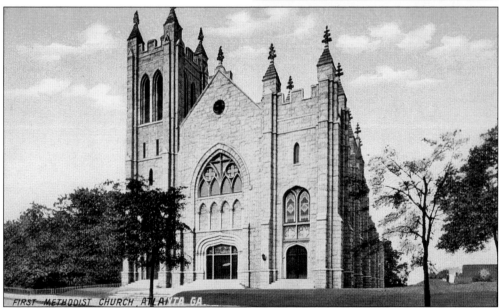

First Methodist Church. In 1903, this church was established at 360 Peachtree Street at Porter Place. It replaced an earlier structure built in 1870 at Peachtree and Houston. An even earlier antecedent was Wesley Chapel, the first church in Atlanta, then Marthasville. A model of the chapel is on display in the church office. (No publishing information available; card sent 1910.)

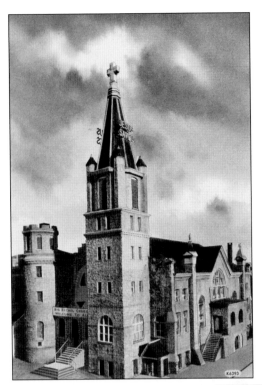

BETHEL A.M.E. CHURCH. Known as "Big Bethel," this African Methodist Episcopal church was organized and built in 1865–66, at the close of the Civil War. Located at 220 Auburn Avenue, it is made of granite blocks from Stone Mountain and indeed looks as solid as a medieval fortress. The tower is complemented with the sign "Jesus Saves," and its well-known pageant, *Heaven Bound*, is presented annually. (Published by R and R News Co., Atlanta.)

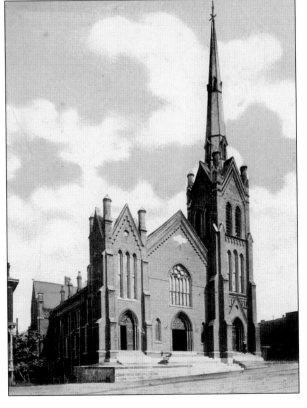

TRINITY METHODIST CHURCH. This early photograph shows Old Trinity Methodist Church at its Whitehall and East Peters location, where it had been a landmark since 1877. In 1911, this property was sold and a new building was erected three blocks east at Washington Street and Trinity Avenue. (No publishing information available; card sent 1909.)

FIRST BAPTIST CHURCH. In 1906, this new building was constructed at Peachtree and Cain Streets. The First Baptist congregation moved to this location after 47 years at the building on Forsyth and Walton Streets. The granite structure of Norman Gothic design remained at this location for 22 years. The subsequent church building, opened in 1930, occupies a four-acre site on Peachtree and is bounded by Fourth, Fifth, and Cypress Streets. (Published by S.L. and Co., Germany; card sent 1908.)

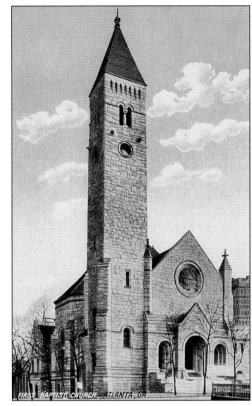

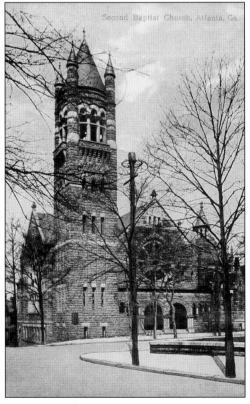

SECOND BAPTIST CHURCH. On September 1, 1854, Second Baptist Church was formed by 19 members of the First Baptist Church who sought a more liberal theology and wanted music in their services. Established at the corner of Washington and Mitchell Streets, the church underwent enlargement between 1861 and 1871; it still stands as Central Baptist Church.

The white-columned Ponce de Leon Baptist stands on the northeast corner of Peachtree Street and East Wesley Road. The Church united with Second Baptist in 1933. In 1939, impressive ceremonies were held when the old bell from the Second Baptist Church was transferred to the new building. (Published by International Post Card Co., New York.)

DRUID HILLS BAPTIST CHURCH. Druid Hills, located in northeast Atlanta, had its beginning in 1908 when Joel Hurt sold 1,492 acres of his already landscaped property to a syndicate to be developed as one of Atlanta's most desirable residential areas. The Druid Hills Baptist Church at Ponce de Leon Avenue and North Highland demonstrates a classic elegance. Dr. Louie D. Newton, its pastor in 1935, was instrumental in bringing to Atlanta Dr. George W. Truett, president of the Baptist World Alliance. Dr. Truett gave an inspiring lecture on religious tolerance to a packed house in the city auditorium. (Published by Curt Teich Co., Chicago.)

BROUGHTON'S CHURCH. One of Atlanta's largest churches is Baptist Tabernacle, a descendant of the old Jones Avenue Baptist Church. Dr. Len G. Broughton, a dynamic and innovative pastor, inspired the construction of a new building at Luckie and Harris Streets. The building opened March 5, 1899, and within ten years, the congregation's growth necessitated an even larger building. (Published by Curt Teich Co., Chicago; card sent 1909.)

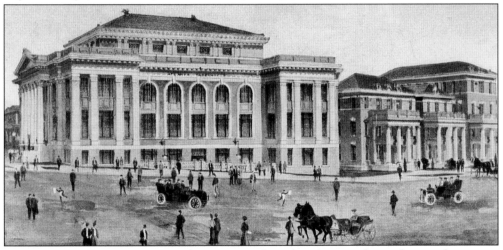

THE ATLANTA TABERNACLE AND AUDITORIUM. Broughton's new tabernacle, seen here as an inspirational plan, was built in 1910. Located at 152 Luckie Street, the red brick, four-story structure is Roman in style, with a seating capacity of 4,000 and complete with quartered oak pews and opera chairs. Since its seven-day dedicatory services in September 1911, the tabernacle has hosted many distinguished pastors. The annual World Bible Conference was one of Dr. Broughton's achievements. (Published by Will Bros., Atlanta; card sent 1909.)

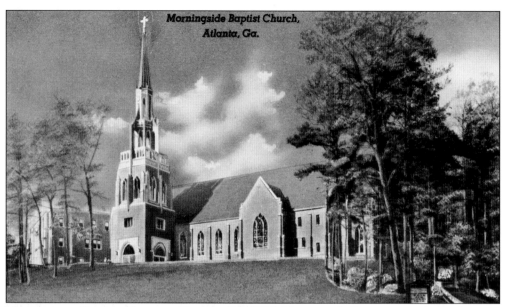

MORNINGSIDE BAPTIST CHURCH. Organized in 1930, Morningside Baptist moved into this new building in October 1951. It is located at 1700 Piedmont Avenue on a 14-acre hillside site, one of the highest in Atlanta. Its impressive tower highlights its notable French Gothic architecture. (Published by Atlanta News Agency.)

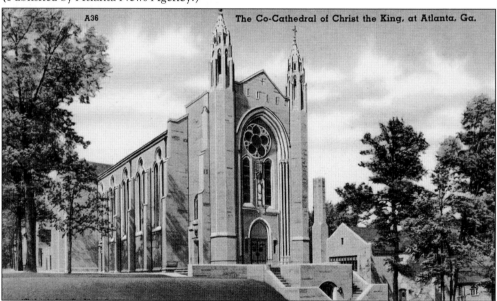

THE CO-CATHEDRAL OF CHRIST THE KING. One of Atlanta's architectural showplaces, the beautiful limestone Co-Cathedral of Christ the King was built in 1938 to the designs of Henry Dagit and Sons of Philadelphia. Dedication ceremonies on January 18, 1939, drew a host of Catholic dignitaries, including Dennis Cardinal Dougherty, Archbishop of Philadelphia, who presided. Three archbishops, 12 bishops, and 150 priests took part, watched by hundreds of interested observers. One of the guests was Hiram Evans, Imperial Wizard of the Ku Klux Klan, on whose property the cathedral was built. (Published by Tichnor Bros., Boston; card sent 1943.)

ENGLISH LUTHERAN CHURCH. The Lutheran Church of the Redeemer, the first English-speaking Lutheran church in Atlanta, was organized in 1903. Its first building was located at Trinity Avenue and Capitol Place. A subsequent building was occupied at Peachtree and Fourth in 1937. The message on the reverse side of this card reads as follows: "The Brotherhood of the Church of the Redeemer cordially invite you to a social evening Wednesday, February 26, 1919, at 7:30." (Published by Witt Bros., Atlanta; card sent 1919.)

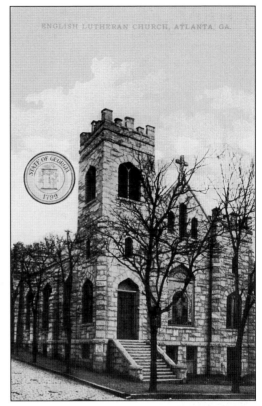

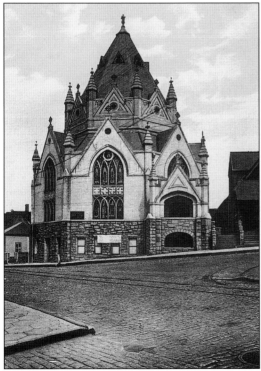

CENTRAL CONGREGATIONAL CHURCH. Organized in Atlanta in 1882, Central Congregational Church was first known as Piedmont Congregational. The name changed in 1885 to Church of the Redeemer, and in 1895 to Central Congregational. The pictured sanctuary was built in 1905 on Ellis Street near Church Street (now Carnegie Way). Because of the escalating downtown business construction and noise, a new location was chosen at 2627 Clairmont Road, and a new sanctuary was occupied in 1930. (Published by Georgia News Co., Atlanta; card sent 1909.)

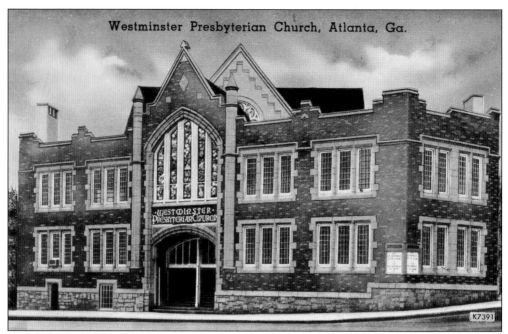

WESTMINSTER PRESBYTERIAN CHURCH. A fortress-like stone church with Gothic influences, Westminster Presbyterian was founded in 1901 at Boulevard and Ponce de Leon Avenue. This structure was later demolished, and a new church was built at 1438 Sheridan Road. (Published by Colourpicture, Boston.)

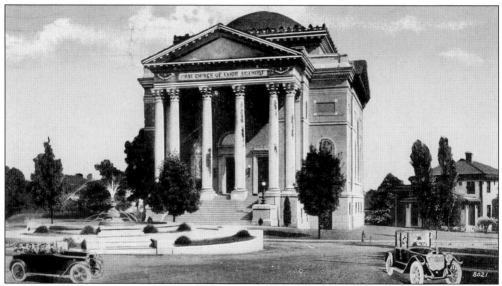

FIRST CHURCH OF CHRIST, SCIENTIST. Christian Science began in Atlanta in 1886 with Miss Julia Bartlett's classes, and as membership grew, meetings were held in various places. In 1899, their first church was completed on Baker Street. In 1914, the new building was completed at 1235 Peachtree Street to the designs of Edward E. Dougherty and Arthur N. Robinson. It has been called "the greatest Christian Science Church south of Baltimore." With its Greek elegance, it is one of Atlanta's stateliest yet most graceful buildings. (Published by Chessler Co., Baltimore; card sent 1924.)

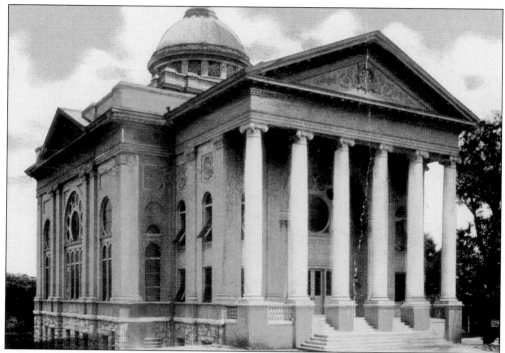

JEWISH SYNAGOGUE. The Jewish community of Atlanta observed services in this temple for the first time in September 1902. Known as the Hebrew Benevolent Congregation, it was organized in 1877 and dedicated its first synagogue at that time. The temple in the picture was located at Pryor and Richardson Streets. In 1931, an impressive new building came into use on Peachtree Street. (Published by Witt Bros., Atlanta; card sent 1908.)

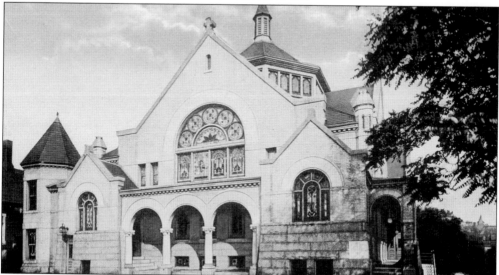

FIRST CHRISTIAN CHURCH. Christian churches in Atlanta have a long history. Organized in the 1850s, the first church building was destroyed in 1864. Another building, constructed in 1869 on Hunter Street between Pryor and Loyd, was exchanged for the present building on the northeast corner of Pryor and Trinity in 1907. The Peachtree Christian Church was built in 1926 at Peachtree and Spring Streets. (Published by Imperial Post Card Co., Atlanta.)

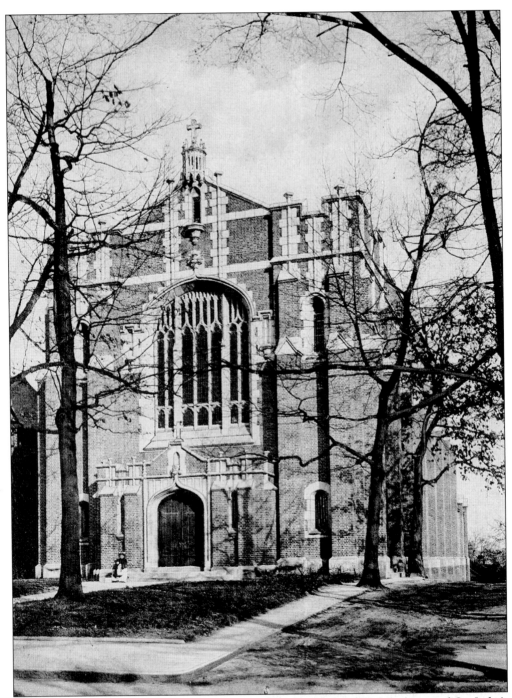

ST. LUKE'S PROTESTANT EPISCOPAL CHURCH. The outstanding Gothic design of St. Luke's Protestant Episcopal Church calls attention to one of the pre-eminent church structures in Atlanta. Located at 435 Peachtree Street, it was built in 1906 of brick and limestone to the designs of P. Thornton Marye. The postcard indicates the year 1909 on the front, along with the name of the rector and the message, "All Peachtree, Pine Street, and Piedmont Ave. cars pass the church." (No publication information available; card sent 1909.)

50

St. Luke's Episcopal Church. The interior of St. Luke's is well provided with Gothic designs and exquisite carvings in the altar area. The large depiction of Christ as Shepherd is especially noteworthy. (No publication information available.)

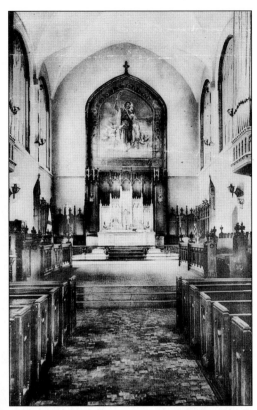

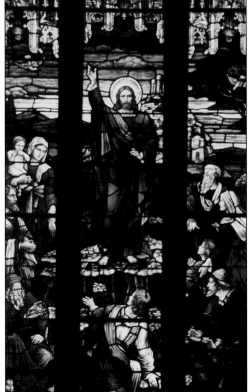

St. Luke's Episcopal Church. A close-up of one of the stained-glass windows shows *Sermon on the Mount* by Heaton, Butler, and Bayne of London. Other windows were crafted by Franz Mayer of Munich and the Willett Studios of Philadelphia. (Published by Mitchell of Petosky, Michigan.)

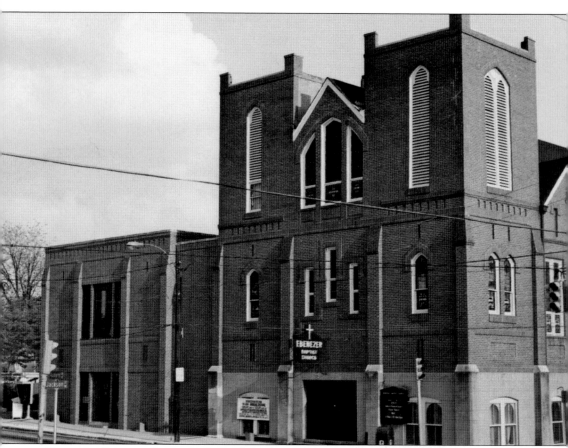

EBENEZER BAPTIST CHURCH. One of the historic landmarks of Atlanta, Ebenezer Baptist is known to all as the place where Martin Luther King, Jr. preached. At the corner of Auburn Avenue and Jackson Street, the Church saw the pastoral tenure of King's father, King's baptism, and later, his ordination as a minister. King established the Southern Christian Leadership Conference here. (Published by Thomas Warren Enterprises, Atlanta.)

Three

HOSPITALS

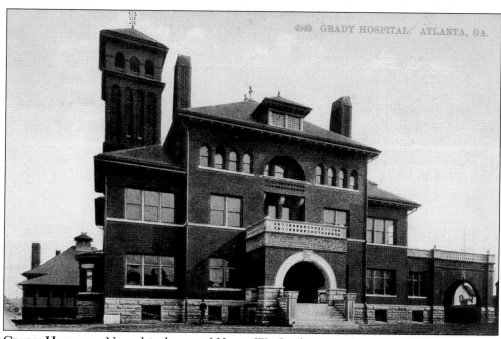

GRADY HOSPITAL. Named in honor of Henry W. Grady, journalist and visionary Atlantan, Grady Memorial Hospital opened on Butler Street in 1892. It offered 100 beds for all emergency patients who could prove citizenship. Ten more rooms were available for paying patients. Today the building houses the School of Nursing and offices of the Mental Health Service. (Published by Adolph Selige Co., St. Louis-Leipzig; card sent 1908.)

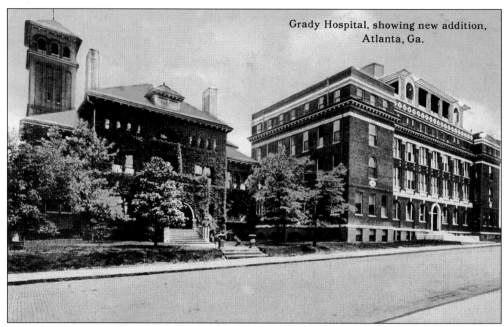

GRADY HOSPITAL, SHOWING NEW ADDITION. Grady Hospital has expanded tremendously through the years to occupy 16 buildings. It is now the largest hospital in the Atlanta area. Its second building, dating from 1912, is shown here, next to the now vine-covered Georgia Hall. (Published by I.F.P. Co., Atlanta.)

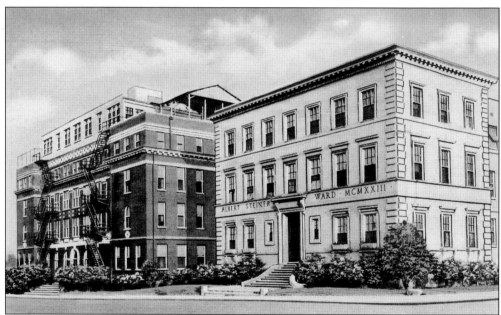

GRADY HOSPITAL AND STEINER CANCER CLINIC. A third building on Butler Street, the Albert Steiner Cancer Clinic was added to the Grady Complex. The Roman numerals on the facade tell us it was built in 1923. Other notable additions have been Atlanta's first blood bank, established at Grady in 1937, and a new building costing $26 million that was dedicated in 1958. (Published by R and R News Co., Atlanta.)

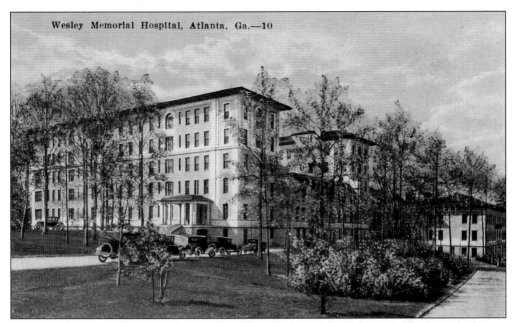

WESLEY MEMORIAL HOSPITAL. In March 1904, Wesley Memorial opened with 50 beds in a downtown Atlanta mansion. In 1922, as a gift to Emory University, Coca-Cola founder Asa Candler donated a 225-bed facility at 1304 Clifton Road that included Wesley Memorial. (Published by E.C. Kropp, Milwaukee; card sent 1936.)

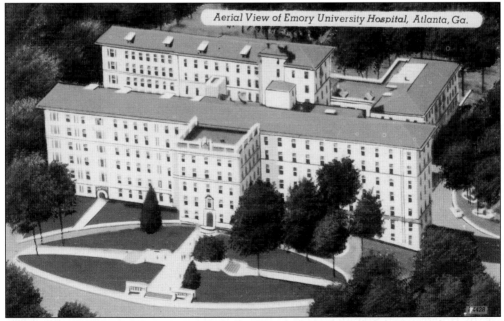

Aerial View of Emory University Hospital, Atlanta, Ga.

AERIAL VIEW OF EMORY UNIVERSITY HOSPITAL. Since 1922, Emory Hospital has been enlarged considerably. Located on the Emory campus, the hospital is part of the university's medical education program and has become one of the country's largest centers for heart surgery and angioplasty. (Published by R and R News Co., Atlanta.)

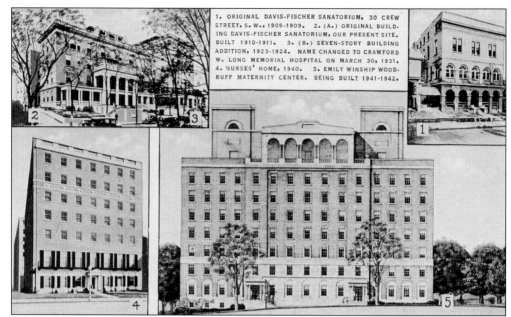

1. ORIGINAL DAVIS-FISCHER SANATORIUM, 30 CREW STREET, S.W., 1908-1909. 2. (A.) ORIGINAL BUILDING DAVIS-FISCHER SANATORIUM, OUR PRESENT SITE. BUILT 1910-1911. 3. (B.) SEVEN-STORY BUILDING ADDITION, 1923-1924. NAME CHANGED TO CRAWFORD W. LONG MEMORIAL HOSPITAL ON MARCH 30, 1931. 4. NURSES' HOME, 1940. 5. EMILY WINSHIP WOODRUFF MATERNITY CENTER. BEING BUILT 1941-1942.

THE CRAWFORD W. LONG MEMORIAL HOSPITAL. The development of this famous hospital is shown in these pictures. The original Davis-Fischer Sanatorium, also known as Atlanta Hospital, was located at 30 Crew Street in 1909. The next building (1910–1911), with later additions (1923–1924), is shown at left. In 1931, the name was changed to Crawford W. Long Hospital, in honor of the Atlanta surgeon who first used ether as anesthesia. (Published by Curt Teich Co., Chicago.)

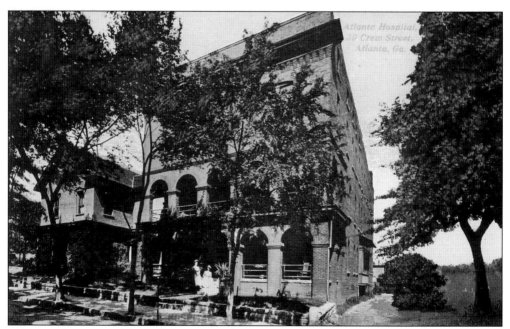

ATLANTA HOSPITAL. The earliest site of the later Crawford W. Long Hospital, this building opened at 30 Crew Street with 26 beds in 1908. It was one of Atlanta's first medical facilities. (Published by Witt Bros., Atlanta; card sent 1912.)

56

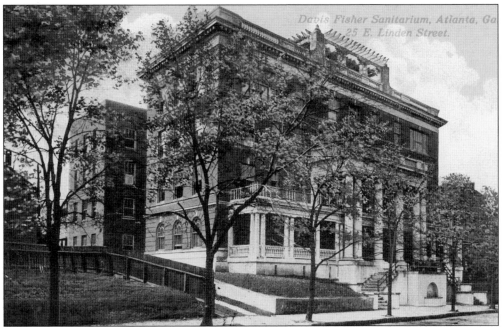

DAVIS-FISCHER SANITARIUM, 25 EAST LINDEN STREET. Located on the block bounded by Peachtree, West Peachtree, Linden Avenue, and Prescott Street, Davis-Fischer occupied larger quarters in 1911. It was to expand much further. (Published by Witt Bros., Atlanta.)

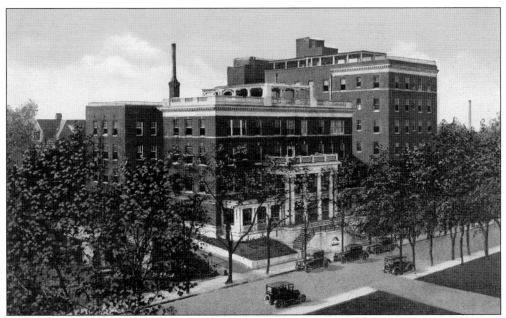

THE CRAWFORD W. LONG MEMORIAL HOSPITAL. In 1931 after the death of co-founder Dr. E.C. Davis, the hospital became Crawford W. Long Memorial. In 1938, Dr. Fischer gave his hospital to Emory University, and and in 1940, a new building program was begun. The eight-story Glenn Building and the seven-story Peachtree Patient Tower were added in the 1970s. (Published by Curt Teich Co., Chicago.)

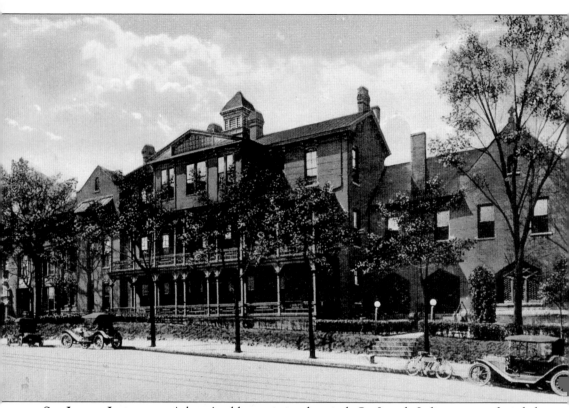

ST. JOSEPH INFIRMARY. Atlanta's oldest existing hospital, St. Joseph Infirmary was founded in 1880 when two Sisters of Mercy were sent from Savannah to establish an institution for the afflicted. Service began in an old residence at 216 North Collins (now Courtland) Street. (Published by I.F. Co., Atlanta.)

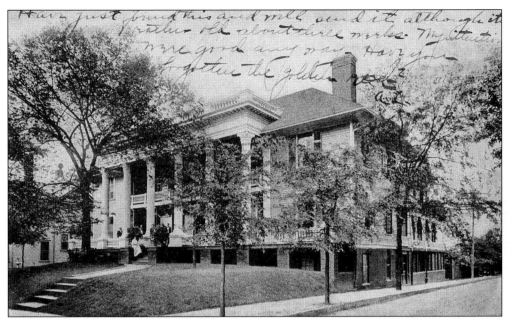

ROBERTSON SANITARIUM. What appears to be a handsome home is a sanitarium that offers patients "water treatment, hygienic diet, osteopathy." In 1908, it was located at 170-4 Capitol Avenue. The sender writes, "Papa is much better this morning from a slight attack of grippe . . . he relished his breakfast." (No publishing information available; card sent 1908.)

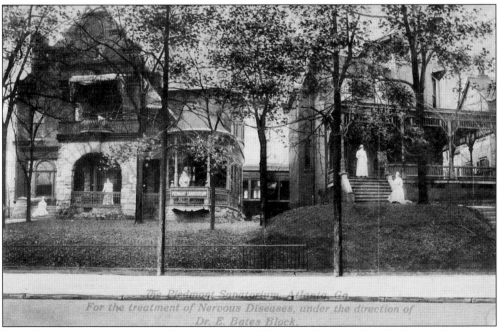

THE PIEDMONT SANITARIUM. Occupying two Victorian houses, the Piedmont Sanitarium specialized in "treatment of nervous diseases under the direction of Dr. E. Bates Block." Assuming that the ladies in white are nurses, one wonders whether anyone was on duty. (Published by Witt Bros., Atlanta.)

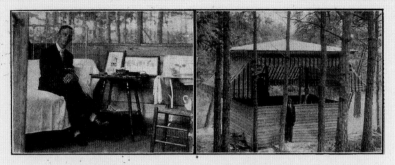

PINE RIDGE SANITARIUM. A tubercular hospital, Pine Ridge shows on this postcard its "outdoor home" and indicates the advantages of patient residence here: "proper altitude, no malaria, luxuries of a city with advantages of country air . . . treatment when necessary, hygienic cooking." (No publication information available; card sent 1908.)

RED CROSS BUILDINGS AND GROUNDS, LAWSON GENERAL HOSPITAL. Located on Carroll Avenue in Chamblee, Lawson General was situated on the site of Camp Gordon, one of 35 cantonments established in the United States during World War I. Abandoned officially in 1919, the camp was re-activated in 1941, when a large airport and the 2,000-bed hospital were constructed. The hospital was named for Thomas Lawson, pre-Civil War Surgeon General of the U.S. Army. (Published by Curt Teich Co., Chicago.)

Four

HOTELS

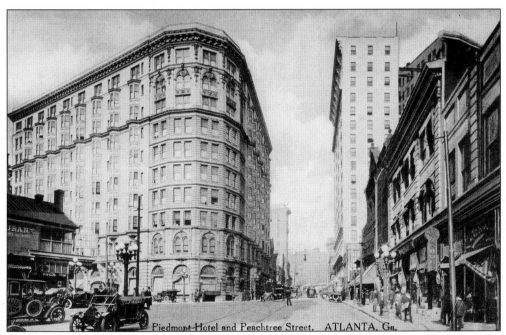

PIEDMONT HOTEL AND PEACHTREE STREET. The handsome new Piedmont Hotel at Luckie and Peachtree Streets opened January 15, 1903. On that day, there was an "open house" attended by hundreds of people who marveled at the beautifully decorated rooms and the elaborate menu in the dining room. It was called "our New York hotel." It was Atlanta's first hotel to emulate the modernity and sophistication of the east. (No publishing information available; card sent 1916.)

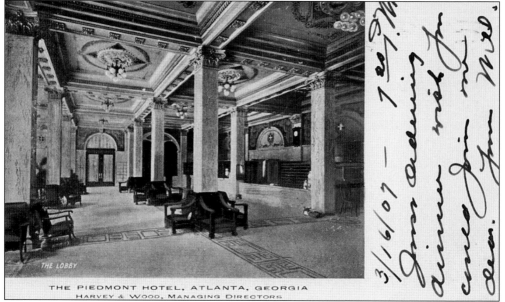

THE PIEDMONT HOTEL, ATLANTA, GEORGIA
HARVEY & WOOD, MANAGING DIRECTORS

THE PIEDMONT HOTEL. A picture of the Piedmont Hotel lobby indicates the classic elegance of its decor. The Piedmont set a local precedent by hiring white bell hops, chambermaids, and a head waiter, though the waiters were black. The sender of this early card, who was required to write the message next to the picture, writes, "Just ordering dinner wish you could Join me dear Your Will." (No publishing information available; card sent 1907.)

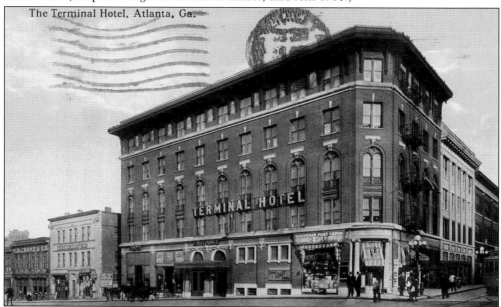

TERMINAL HOTEL. Opened in 1908, the five-story Terminal Hotel was located at Spring and Mitchell Streets. Two major tragedies haunt this hotel. In 1936, a fire claimed the lives of 26 people; in 1938, a much worse fire claimed the lives of 34. The hotel was destroyed; the fire was Atlanta's worst hotel fire up to that time. In this early picture, note the corner shop window: Coca-cola and souvenir postcards are sold here. (Published by I.F. Co., Atlanta; card sent 1915.)

ARAGON HOTEL. On November 14, 1892, Hotel Aragon opened on the corner of Peachtree and Ellis Streets. Six stories high, it offered 125 tastefully furnished rooms, and for guests' convenience, there were four elevators. The cuisine in the dining room became famous; six-course dinners featured sirloin steaks, lobster, and fine wines. Many theatrical headliners and other famous visitors stayed here. In 1930, the Aragon, having served its generation well, closed. Its furniture was auctioned away, and the building was demolished. It was later replaced by the Collier Building. (Published by Washington News Co., Washington, D.C.)

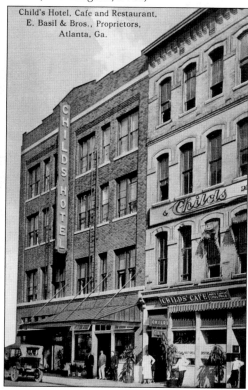

CHILD'S HOTEL, CAFE AND RESTAURANT. A hotel of lesser ambience than the Aragon, Child's was located "in the heart of the city" and had "electric car service to and from all depots." Further amenities included single rooms with bath or "rooms en suite," hot and cold running water, electric lights, and a telephone. Rates were $1.50 "with privileges," and $2 with private bath. There was a private dining room for ladies. (Published by I.F. Co., Atlanta; card sent 1915.)

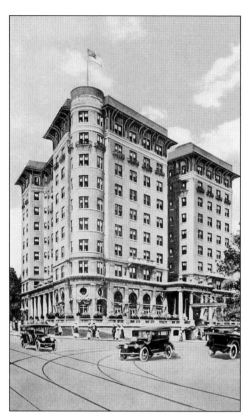

GEORGIAN TERRACE HOTEL. On October 2, 1911, over 5,000 people came to admire the new Georgian Terrace Hotel at Peachtree and Ponce de Leon. Costing $1.5 million, its white walls, marble columns, and superb murals and hangings created an impression carried out in its motto: "a Parisian hotel on a noted boulevard in a metropolitan city." (Published by I.F. Co., Atlanta.)

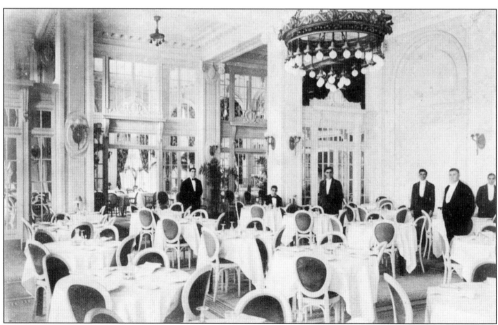

THE GEORGIAN TERRACE RESTAURANT AND TERRACE GARDEN. Elegant decor in the dining room complements the rest of "the hotel beautiful." Notice that the bell boys, maids, and the waiters are white. (No publishing information available.)

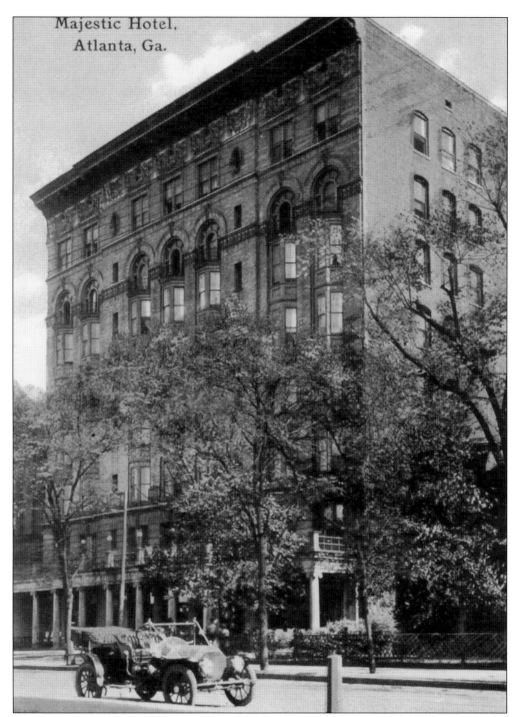

MAJESTIC HOTEL. Another Peachtree Street hotel, the Majestic was situated opposite the governor's mansion on Cain Street. Its advertising indicated that it was "located far enough from the business district to be away from the noise, smoke, and dust, yet in walking distance of all churches, theatres, and shopping district." It claimed to be fireproof, "a place where you can safely send your wife, mother, or sister." (Published by I.F. Co., Atlanta; card sent 1912.)

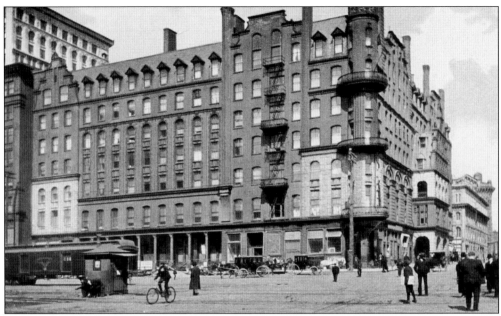

THE KIMBALL HOUSE. A pioneer Atlanta hotel, the Kimball House was built in 1870 and burned in 1883. The second Kimball House, pictured here, was built in 1885 and became the political headquarters of Georgia. President Cleveland was entertained here in 1887. The picture shows its proximity to the railroad tracks. (Published by Raphael Tuck and Sons, London.)

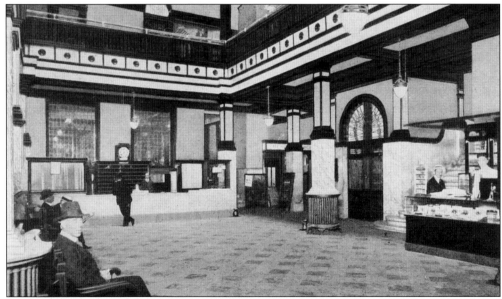

SECTIONAL VIEW OF LOBBY, KIMBALL HOUSE. The new Kimball was seven stories tall and contained 357 "large airy sleeping chambers" and 22 public rooms. The building was described as "Dutch Renaissance, in which the New York of two centuries ago was built." The lobby decor seems sparse, probably reflecting the taste of many masculine visitors. The lobby and billiard rooms were the favorite meeting places of Atlanta's young men. (Published by Imperial Post Card Co., Atlanta.)

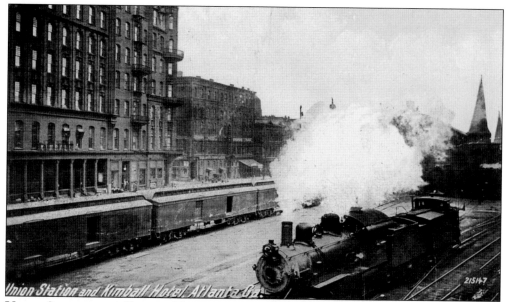

UNION STATION AND KIMBALL HOTEL. Next to the tracks and at right angles to the Union Terminal, the Kimball was subject to the noise and smoke of passing trains, as this picture demonstrates. Both Pryor and Whitehall Streets crossed the tracks here at grade. The new Plaza Park, achieved in 1949, now covers the area occupied by the trains. The Kimball was torn down in 1959. (Published by Leighton & Valentine, New York; card sent 1913.)

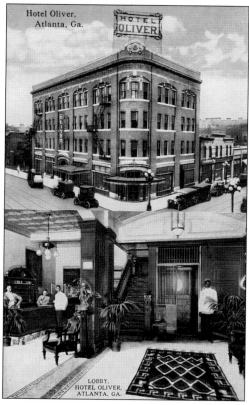

HOTEL OLIVER. At the corner of Pryor and Houston Streets, Hotel Oliver was situated opposite the Candler Building. It advertises its "European Plan, in the heart of the city. Rooms without bath $1.00. Rooms with private bath, $1.50. Elegantly furnished, all rooms have outside exposure." The lobby shows potted palms, a sculpture on a pedestal, and an elevator with an attendant—evidences of genteel hospitality. (Published by Hotel Oliver, Atlanta.)

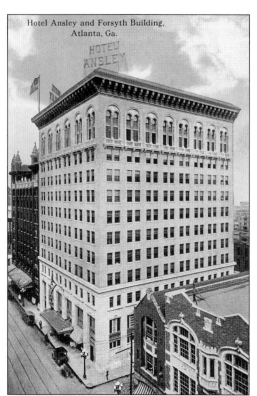

Hotel Ansley and Forsyth Building.
Atlanta, Ga.

HOTEL ANSLEY AND FORSYTH BUILDING.
At Luckie and Forsyth Streets, the new
Ansley was named for its builder, Edwin P.
Ansley. The million dollar hotel opened
June 30, 1913, with a glittering formal
opening and reception. Local press reported
that "Atlanta's Four Hundred and Atlanta's
four thousand thronged . . ." Five orchestras
played, and an elaborate banquet was served.
The lobby featured green onyx columns, and
oil paintings of historic Atlanta decorated
the walls. It was "the South's finest and
most modern hotel." (Published by I.F. Co.,
Atlanta; card sent 1915.)

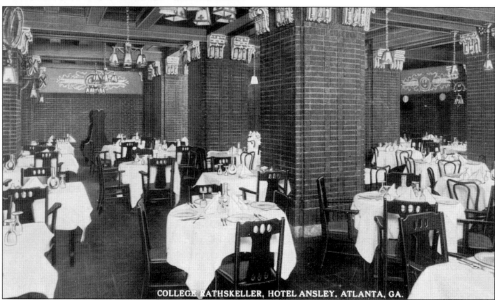

COLLEGE RATHSKELLER, HOTEL ANSLEY, ATLANTA, GA.

COLLEGE RATHSKELLER, HOTEL ANSLEY. One of two major restaurants within the hotel was
the Rathskeller, also known as the College Inn, which was decorated to remind patrons of its
German prototype. Another favorite room was the Italian Cafe, which was decorated along
more sophisticated lines. There were many notable rooms in the Ashley, including 450 sleeping
rooms, a ballroom, reception parlors, and a banquet hall. (Published by I.F. Co., Atlanta; card
sent 1915.)

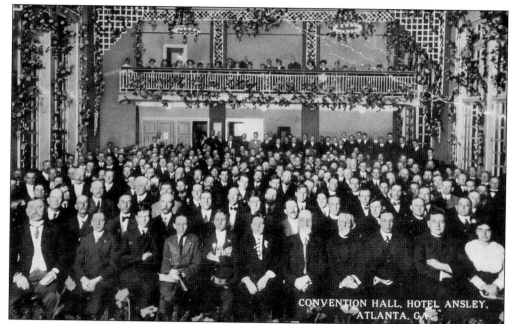

CONVENTION HALL, HOTEL ANSLEY. The convention group pictured is the Brotherhood of St. Andrew, and this clear picture must have been a satisfying remembrance to the members. It is notable that few women are seated downstairs, though a number of them are seated in the rather small balcony. The sender of the card comments, "The Con. is just fine. Homer Rhodeaver Sunday's song leader is just grand. I had the pleasure of meeting him and Chas. H. Gabriel." (Published by I.F. Co., Atlanta; card sent 1916.)

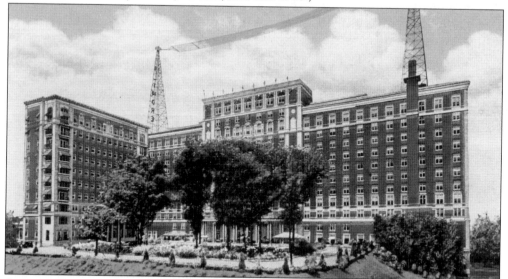

ATLANTA BILTMORE HOTEL. Costing more than $6 million, the Biltmore opened in 1924 with a gala celebration. The new edifice, on West Peachtree between Fifth and Sixth Streets, was splendid with its majestic portico, marble terrace, and carefully planned garden. Chef Eugene Bouvier served a royal dinner, after which the main rooms were cleared for dancing to the music of the ubiquitous Enrico Leide's orchestra. On the roof, we see the towers of WSB Radio, "the voice of the South." (Published by Imperial Post Card Co., Atlanta.)

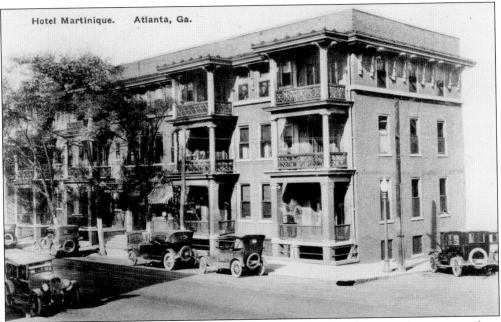

HOTEL MARTINIQUE. Atlanta, Ga.

HOTEL MARTINIQUE. This hotel has no identification other than the name. It appears to be a modest neighborhood dwelling with apartment-like balconies. The automobiles indicate the decade of the 1920s. (Published by the Albertype Co., Brooklyn, N.Y.)

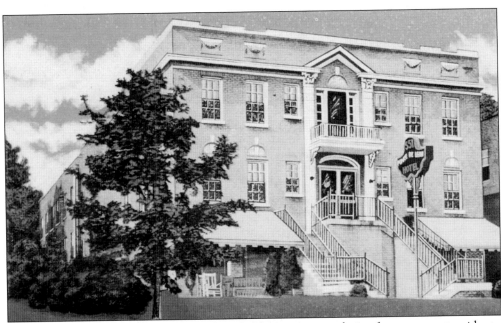

PONCE DE LEON HOTEL. This small hotel, probably an accommodation for permanent residents, was located at 551 Ponce de Leon Avenue NE. It contained 50 rooms and 50 baths—an indication of its modernity. There were no rooms here "with privileges" that cost less than others. (Published by Art Tone Assoc. Litho., Des Moines.)

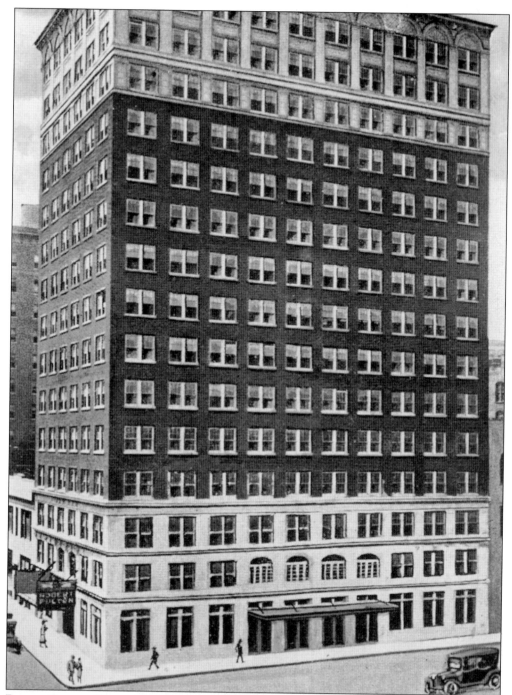

ROBERT FULTON HOTEL. At 15 stories, the Robert Fulton Hotel—Atlanta's tallest—was opened in September 1924 at Luckie and Cone Streets. It was simply designed of maroon brick and terra cotta and contained 300 rooms, each with private bath; each room featured a ceiling fan and circulating ice water. The meeting rooms and coffee shop were air-conditioned. In 1950, after a change of ownership, the name was changed to The Georgian. (Published by R and R Magazine Agency, Atlanta.)

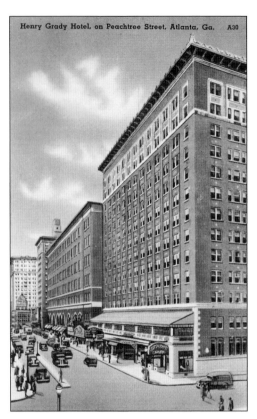

Henry Grady Hotel, on Peachtree Street, Atlanta, Ga. A30

HENRY GRADY HOTEL. Named for the influential and legendary journalist, the Henry Grady opened in 1924 at Peachtree and Cain Streets. It contained 550 rooms in its 13 stories. The sender of this card comments, "This hotel would hold all the inhabitants of many small towns . . . you can recommend it to anyone." In 1974, it was destroyed to make way for the cylindrical Westin Peachtree Plaza Hotel. (Published by R and R News Co., Atlanta; card sent 1945.)

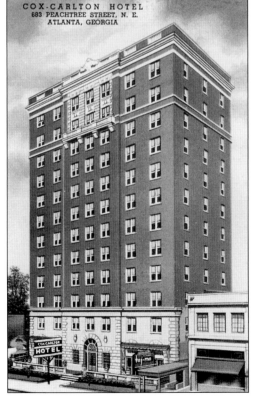

COX-CARLTON HOTEL
683 PEACHTREE STREET, N. E.
ATLANTA, GEORGIA

COX-CARLTON HOTEL. Somewhat smaller than the Grady, but built along the same architectural lines, is the Cox-Carlton at 683 Peachtree Street NE, just north of the Georgian Terrace. Opened in 1925 and known as a "bachelor hotel," it contained 150 rooms and baths in its 12 stories. When this card was printed, William J. Folsom Jr. was manager. (Published by Curt Teich Co., Chicago.)

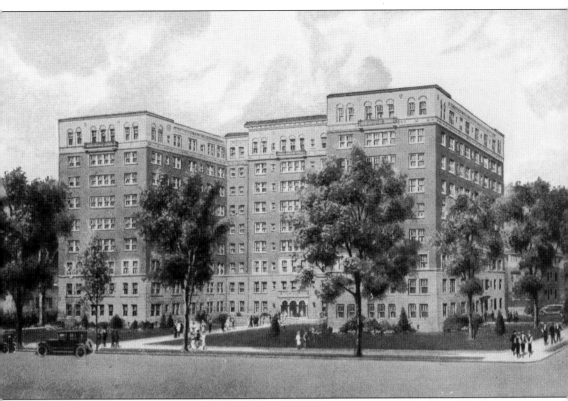

HOTEL BRIARCLIFF. Called a hotel, but more accurately functioning as an apartment house, the Briarcliff was built in 1925 at 1050 Ponce de Leon Avenue. The elaborate structure contained "luxury suites; apartments with or without kitchen-bars." There were rates and accommodations for transients as well as residentials. (Published by Curt Teich Co., Chicago.)

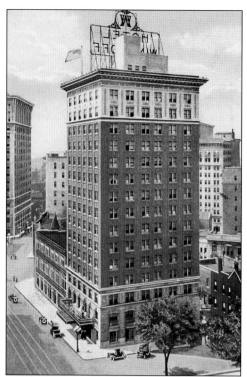

THE WINECOFF HOTEL. The opening of the Winecoff, named for its builder, William F. Winecoff, took place on October 30, 1913, with a gala reception. The *Atlanta Journal* called it "the magnificent structure that has joined Atlanta's hostelries which rank with the finest in the South." The elevators and the baby-blue and white bridal suite were especially admired. The bridal suite was decorated with Harrison Fisher's famous drawings that illustrated love, courtship, marriage, and the happy life. (Published by I.F. Co., Atlanta; card sent 1922.)

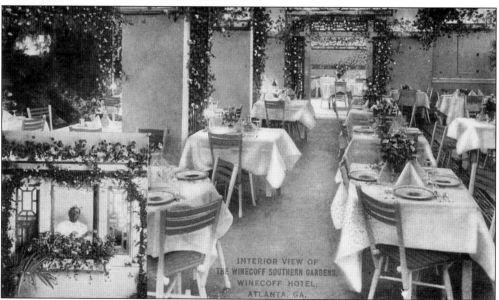

INTERIOR VIEW OF THE WINECOFF SOUTHERN GARDENS. Furnished throughout with mahogany, the Winecoff boasted of a superb lobby, mezzanine, and other special rooms such as the one pictured here. Elegance prevailed; for good luck there was no 13th floor. The hotel was advertised as "absolutely fireproof." On December 7, 1946, the middle floors were gutted by flames, and since the hotel had no fire escapes or sprinklers, 119 people died; 100 others were injured. It was the worst hotel disaster in U.S. history. (Published by S.D. Zacharias, Atlanta; card sent 1915.)

74

Five

COLLEGES

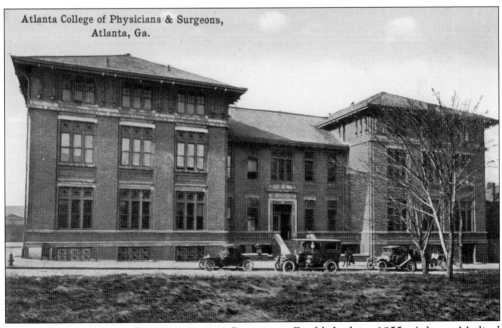

ATLANTA COLLEGE OF PHYSICIANS AND SURGEONS. Established in 1855, Atlanta Medical College joined Southern Medical College and Southern Dental College in 1898 to become the Atlanta College of Physicians and Surgeons. It became part of Emory University in 1915. (Published by Imperial Fruit Co., Atlanta; card sent 1908.)

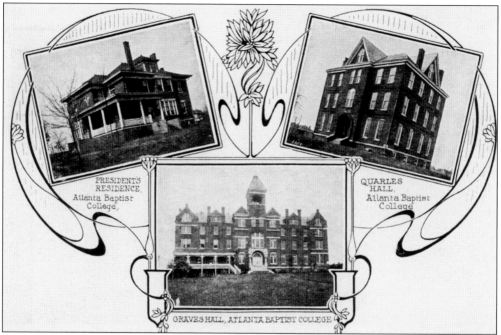

ATLANTA BAPTIST COLLEGE. One of several black colleges in the Atlanta University complex, Atlanta Baptist originated in Augusta; it relocated in Atlanta in 1879, first as Atlanta Baptist Seminary, then changing its name to Morehouse College. It is this country's only all-male, predominantly black liberal arts college. Its most famous alumnus is Martin Luther King, Jr. (No publishing information available; card sent 1909.)

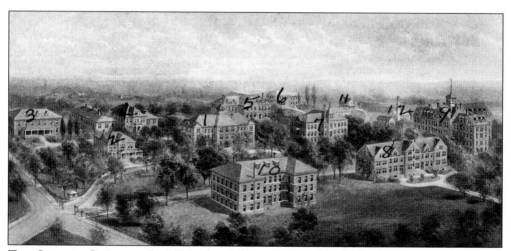

THE SPELMAN SEMINARY. In 1881, the Atlanta Baptist Female Seminary opened with 11 students; it moved temporarily to McPherson Barracks and became Spelman Seminary. The correspondent for this postcard has numbered the buildings of a later time: #1 is Rockefeller Hall; #2 is the president's home; #3 is the nurses' home; #4 is MacVicar Hospital; and #10 is the home economics building. This campus indicates the spectacular growth of the college. It is one of the oldest institutions dedicated to the education of black women. (No publishing information available.)

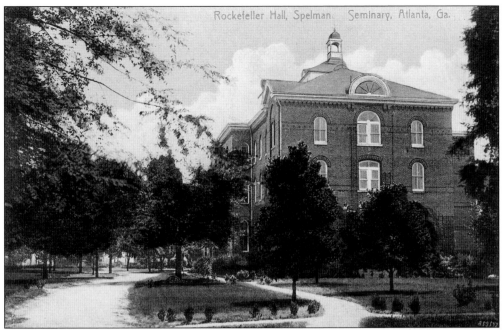

ROCKEFELLER HALL, SPELMAN SEMINARY. Built at a cost of $40,000 donated by John D. Rockefeller, Jr., the 135-foot Rockefeller Hall opened in November 1886 as a student dormitory. Spelman Seminary was named for Rockefeller's mother-in-law, Lucy Henry Spelman. (Published by A.P. Bedou, New Orleans; card sent 1910.)

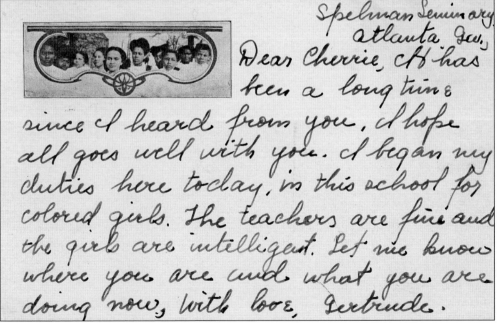

Spelman Seminary
atlanta Ga.,
Dear Cherrie, It has been a long time since I heard from you, I hope all goes well with you. I began my duties here today, in this school for colored girls. The teachers are fine and the girls are intelligent. Let me know where you are and what you are doing now, with love, Gertrude.

"DEAR CHERRIE . . ." This unusual postcard illustrates a type used between 1898 and 1907, when only the addressee and address were allowed on the stamped side of the card. This picture is unusually small, and the message is longer than most cards would have space for. The postmark validates its age. (No publishing information available; card sent 1908.)

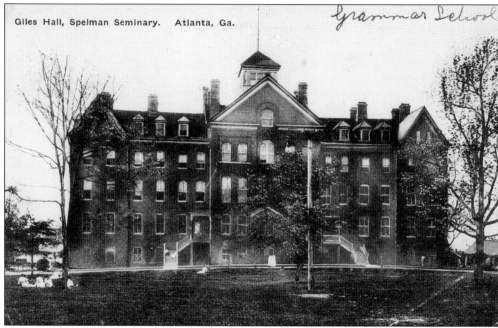

Giles Hall, Spelman Seminary. Atlanta, Ga. *Grammar School*

GILES HALL, SPELMAN SEMINARY. On a previous postcard showing Spelman Seminary (page 76), Giles Hall is #9 on the far right. It was, as this correspondent tells us, the grammar school. She says further, "Our campus is a lovely spot. Too near the city—'tis very smoky but I think everyone loves it." (Published by Albertype Co., Brooklyn, N.Y.; card sent 1921.)

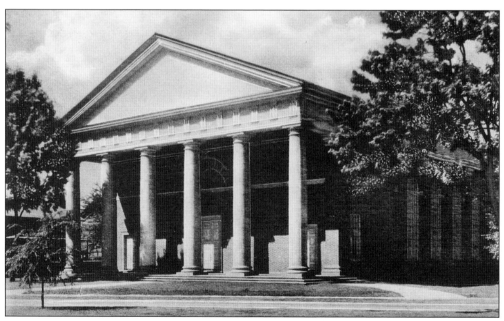

SISTERS CHAPEL, SPELMAN COLLEGE. In 1924, Spelman Seminary's name was changed to Spelman College. Sisters Chapel was completed in 1927 as a memorial to Laura Spelman Rockefeller and Maria Spelman. The chapel has a seating capacity of 1,200 and features a fine organ. (Published by Albertype Co., Brooklyn, N.Y.)

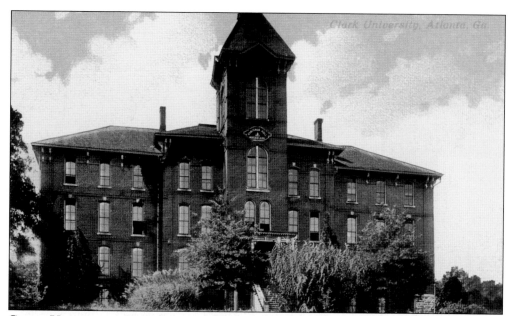

CLARK UNIVERSITY. One of the complex of Atlanta's black colleges, Clark was founded in 1869 as a co-educational institution by the Freedmen's Aid Society of the Methodist Episcopal Church. In 1877, it was chartered as Clark University, and its first brick building, Chrisman Hall, seen here, was erected in 1880. After its inclusion in the University Center plan in 1940, its name was changed to Clark College, and it moved from McDonough Road to Chestnut Street, opposite the Atlanta University Administration Building. (Published by Witt Bros., Atlanta.)

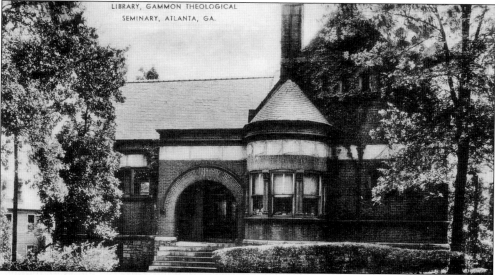

LIBRARY, GAMMON THEOLOGICAL SEMINARY. Located on the McDonough Road, Gammon Theological Seminary opened in 1883 on a lot adjacent to Clark University. At first associated with Clark, it achieved independent status in 1888 and was named for Elijah H. Gammon, a retired Methodist clergyman who gave a substantial endowment. The Gilbert Haven Library has a notable African collection and several early Bibles. The building was constructed in 1889. (No publication information available; card sent 1908.)

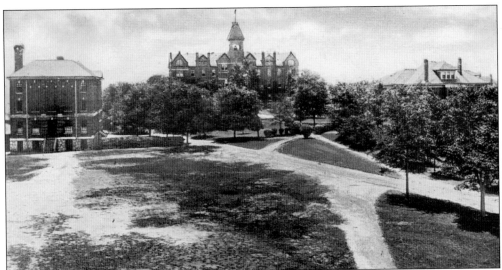

MOREHOUSE COLLEGE. Originating in Augusta in 1867, this college, then called the Augusta Institute, had only a handful of students, most of whom were born into slavery. After moving to Atlanta in 1879, the name was changed to Atlanta Baptist Seminary, then to Atlanta Baptist College in 1897. The name Morehouse College came in 1913, to honor Dr. Henry Lyman Morehouse, secretary of the American Baptist Home Mission Board. It is one of the seven institutions making up the Atlanta University Center. (Published by Hopkins Book Concern, Atlanta.)

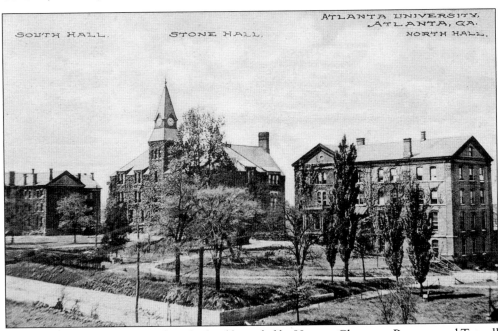

ATLANTA UNIVERSITY. Located on the land bounded by Hunter, Chestnut, Parsons, and Tatnall Streets, Atlanta University was chartered October 15, 1867. Edmund A. Ware was the first president. Pictured are the three oldest buildings: North Hall (1869), now Gaines Hall; South Hall (1870), and Stone Hall (1880), now Fountain Hall. Atlanta University now grants only graduate degrees. (No publication information available; card sent 1912.)

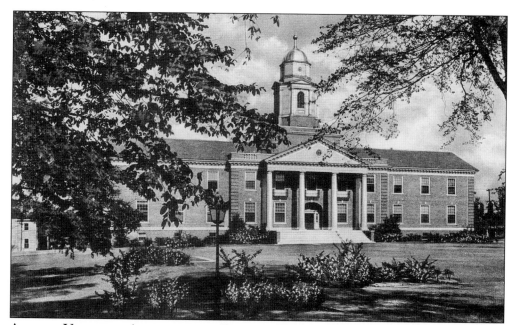

ATLANTA UNIVERSITY ADMINISTRATION BUILDING. Harkness Hall, the administration building, was built in 1932–33 and contains offices governing the university. The post office and bookstore are also housed here, as well as seminar rooms and a commissary. (Published by Albertype Co., Brooklyn, N.Y.)

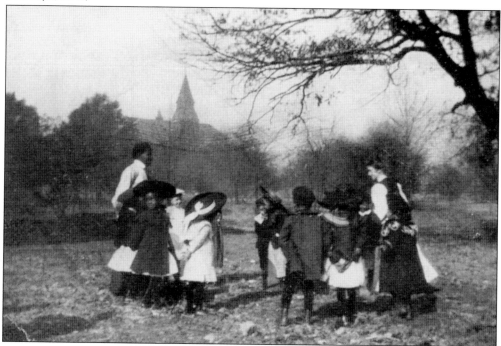

"A GLIMPSE ACROSS THE CAMPUS . . ." A scene on the campus of Atlanta University reveals an activity of the "normal school," c. 1905. It is interesting to note that there is a white female teacher and a black male teacher; there are both black and white children in the group. (No publication information available.)

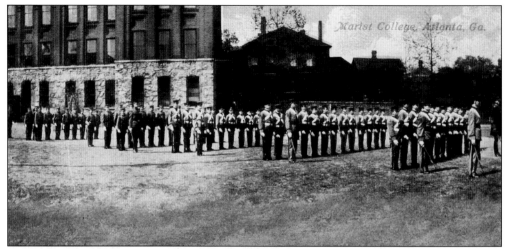

MARIST COLLEGE. Next door to the Sacred Heart Church at Peachtree and Ivy, the Marist College was established in 1901 as a military day school operated by the Marist Order of the Catholic Church. It was, in fact, non-sectarian in its operation, and its students came from many denominations. In 1917, a Reserve Officers Training Corps unit was established that enabled graduates to obtain army commissions. The school has no college department but offers sound preparations for college entrance in its junior and senior high schools. (Published by Witt Bros., Atlanta.)

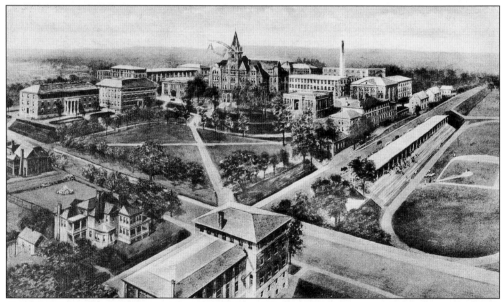

GEORGIA SCHOOL OF TECHNOLOGY, BIRD'S-EYE VIEW OF CAMPUS AND BUILDINGS. In 1886, legislators established a state technological school, and in 1888, the first classes convened with 129 students. The campus occupies 55 acres, just north of the center of Atlanta, and has 32 compactly grouped buildings. The sender of this card in 1918 writes, "Hold this card up to the light and a pin hole will show you my class room." Though not visible here, the hole designates the front corner, top floor of the second building on the left. (Published by Albertype Co., Brooklyn, N.Y.; card sent 1918.)

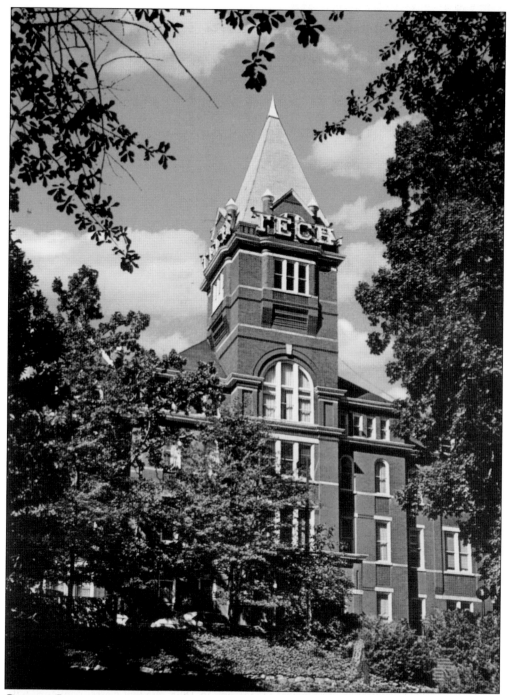

Georgia Institute of Technology's Famous Tech Tower. This administration building was one of five erected in 1888; it dominates the campus with its spire emblazoned on all four faces with the word TECH. Georgia Tech offers Bachelor's degrees in nine departments, including engineering, architecture, chemistry, and industrial management. Both military and naval units of ROTC are maintained here. (Published by Aerial Photography Services, Atlanta.)

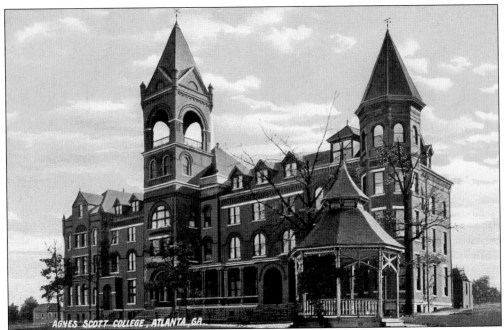

AGNES SCOTT COLLEGE. Established in 1889 by the efforts of Col. George W. Scott, a wealthy industrialist, the Decatur Female Seminary opened with 60 students. In 1891, Main Hall was built with Colonel Scott's money, and the school was then named Agnes Scott College. Progressing through the years in academic excellence and superior reputation, it became the first school in Georgia to be accepted into the Southern Association, and it was the first college in the United States to be invited to apply for membership in Phi Beta Kappa. (Published by International Post Card Co., N.Y.; card sent 1907.)

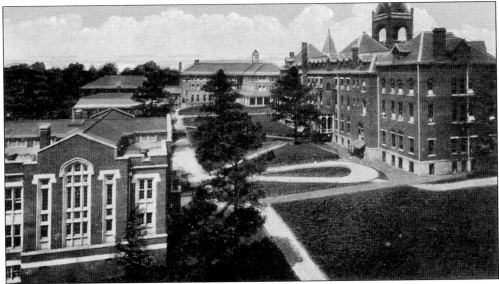

AGNES SCOTT COLLEGE FOR GIRLS. A fuller view of the 30-acre campus shows several more of the 36 buildings, which were all designed in red brick collegiate Gothic style. In the 1930s, Agnes Scott had about 500 students and 60 teachers. (Published by R and R News Co., Atlanta.)

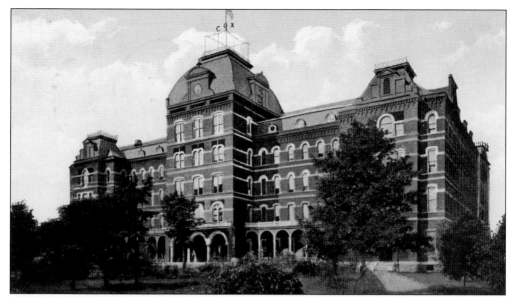

MAIN BUILDING, COX COLLEGE AND CONSERVATORY, COLLEGE PARK. In 1895, the Southern Female Seminary moved from LaGrange to College Park and re-opened as Cox College; in fact, the establishment of the college here occasioned the change in name of the town from its former name, Manchester. College Park is a residential suburb of Atlanta 8 miles to the south. In 1938, Cox College closed its doors and the building was razed. A new park and civic center now occupy the site. (No publisher; printed in Great Britain; card sent 1907.)

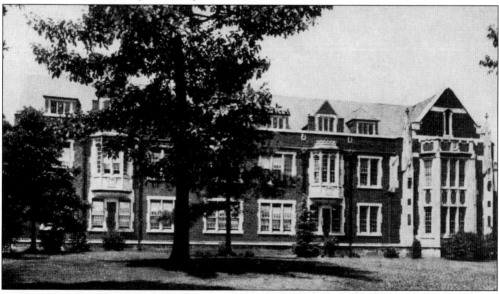

CAMPBELL HALL, COLUMBIA THEOLOGICAL SEMINARY, DECATUR. A Presbyterian institution chartered in 1828 in Lexington, Georgia, the Theological Seminary of the Synod of South Carolina and Georgia moved to Columbia, South Carolina, where it remained for nearly 100 years. On September 14, 1927, the Columbia Theological Seminary moved to a 57-acre tract in Decatur, just east of Atlanta. Pictured is the Virginia Orme Campbell Administration Building. Courses in Biblical, historical, and practical theology lead to Bachelor of Divinity degrees, as well as master's and doctor's degrees. (Published by Eagle Post Card View Co., N.Y.)

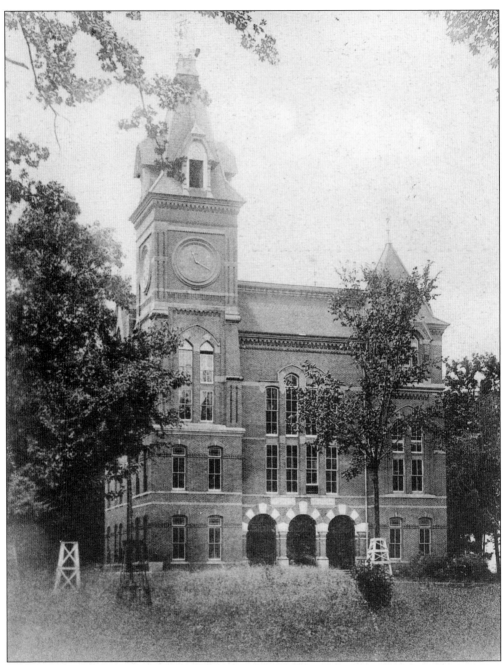

EMORY COLLEGE, OXFORD, GEORGIA. Named for Bishop John Emory, a scholarly and progressive Methodist who died in 1835, Emory College was chartered in 1836 in Oxford, near Covington, Georgia. The classical courses of study were similar to those at Yale. Until the early 1900s, Emory at Oxford flourished and graduated a number of prestigious persons. An early president was Augustus Baldwin Longstreet, author of *Georgia Scenes*. Pictured is Seney Hall, whose bell was presented by Queen Victoria to Emory President Alexander Means in 1855. (Published by Rotograph Co., N.Y; card sent 1906.)

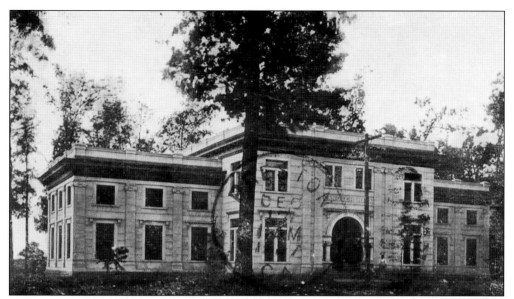

LIBRARY BUILDING, EMORY COLLEGE, OXFORD, GEORGIA. Emory at Oxford graduated its first class in 1841. Among distinguished later graduates were Joseph S. Key, first Emory man to become a Bishop; Lucius Q.C. Lamar, who became a Supreme Court Justice; and Isaac S. Hopkins. Dr. Hopkins, noted for his work in engineering at Emory, was asked to organize a state engineering school in 1886. He became the first president of Georgia Tech. (No publication information available; card sent in 1906.)

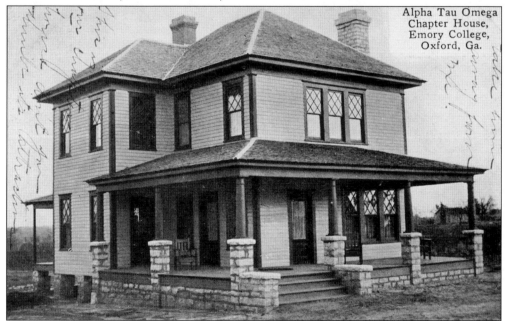

ALPHA TAU OMEGA CHAPTER HOUSE, EMORY COLLEGE, OXFORD. The Temple of the Mystical Seven, the first chapter of a national fraternity established in the South, was organized at Emory in 1840. Others soon followed, and fraternity rivalry was great. The sender of this card in 1912 comments, "This is our chapter house. Don't you think it is attractive?" (No publishing information available; card sent 1912.)

87

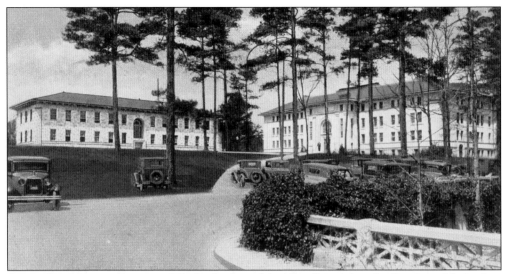

EMORY UNIVERSITY, ATLANTA. The leadership of Asa Candler within the Southern Methodists and his enormous generosity resulted in the re-location of Emory in the Druid Hills section of Atlanta in 1915. Through numerous negotiations and a gift of $1 million, plus a deed for 75 acres of land, Candler energized the new Emory into being. At the time of this 1930s card, the campus had expanded to 220 acres and contained 15 buildings. (Published by Imperial Post Card Co., Atlanta.)

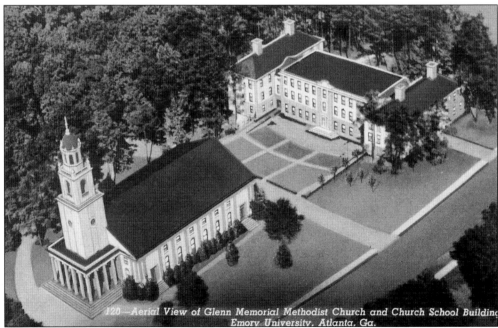

AERIAL VIEW OF GLENN MEMORIAL METHODIST CHURCH AND CHURCH SCHOOL BUILDING, EMORY UNIVERSITY. This cream-colored, stucco Methodist church stands near the entrance of the Emory campus at North Decatur and Oxford Roads. The Glenn Memorial Church, built in 1931, was given by Mrs. Charles H. Candler and Thomas K. Glenn in memory of their father Dr. Wilbur Fisk Glenn, a well-known Methodist minister. It serves both as a community church and as a university chapel. (Published by R and R News Co., Atlanta.)

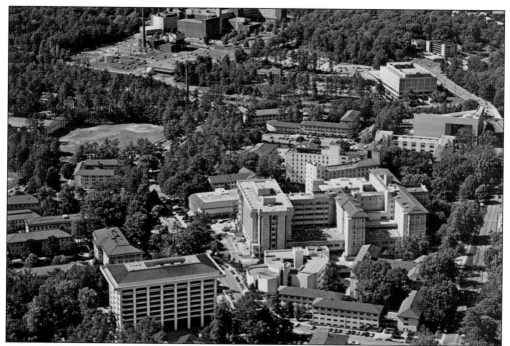

EMORY UNIVERSITY. Famous world-wide for its schools of medicine, law, theology, nursing, and business administration, Emory University stands as a monument to the inspirational leadership and the philanthropic generosity of the Candler family. (Published by Aerial Photography Services, Atlanta.)

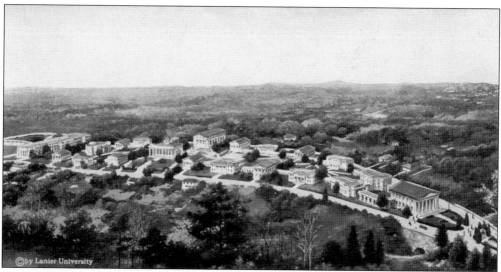

LANIER UNIVERSITY, HIGHLAND AVENUE, ATLANTA. Established in 1917, Lanier University was founded by Charles Lewis Fowler, a Baptist minster, who envisioned an "all-Southern Baptist University" whose buildings would echo the classical lines of Monticello and Mount Vernon. Financial support, however, dwindled, and Lanier was bankrupt by 1922. In later years Congregation Shearith Israel bought the property and renovated its one existing building. The picture here is probably the conceptualization provided in 1917 by Atlanta architect Ten Eyck Brown. (Published by I.F. Co., Atlanta.)

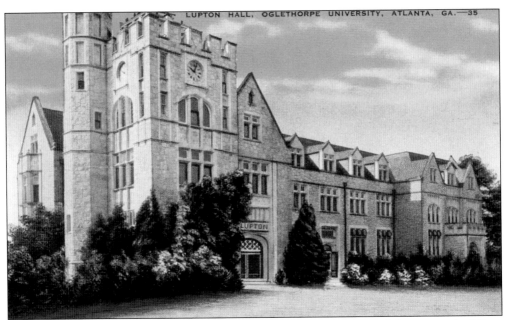

LUPTON HALL, OGLETHORPE UNIVERSITY. In 1920, Lupton Hall, one of three main buildings grouped near the entrance to the campus, was built from Georgia blue granite and white limestone; the building was funded through the generosity of John T. Lupton of Chattanooga. Located on Peachtree Road about 12 miles north of downtown Atlanta, Oglethorpe, named for James Edward Oglethorpe, founder of Georgia, is a campus of nearly 600 acres. Its history dates back to 1823 in Milledgeville. The present institution was chartered in 1913. (Published by R and R News Co., Atlanta.)

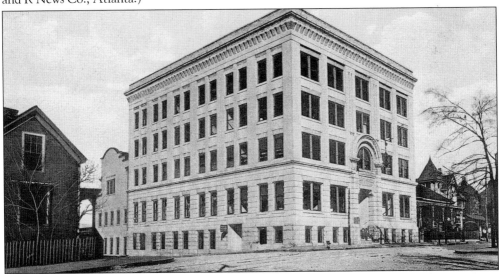

ATLANTA SCHOOL OF MEDICINE. By 1898, several medical schools had merged to become the Atlanta College of Physicians and Surgeons; however, dissatisfied with the administration, one group broke away and established the School of Medicine pictured here, which opened in 1905. The college had its own hospital and offered increased facilities for practical demonstrations. It united with its parent institution again in 1913, and in 1915, it became affiliated with Emory. (Published by Georgia News Co., Atlanta.)

90

Six

PARKS

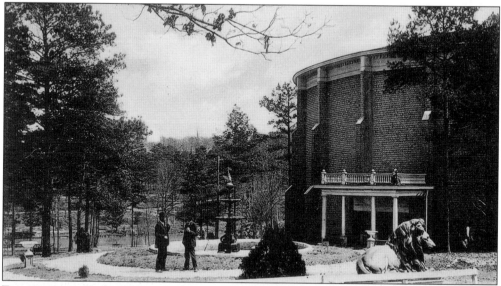

ENTRANCE TO GRANT PARK, ATLANTA. The oldest park in Atlanta, Grant Park covers 144 acres bounded by Cherokee Avenue, Atlanta Avenue, South Boulevard, Park Avenue, and Sidney Street. It has many miles of shaded walks and paved driveways, and recreational facilities that include tennis courts, baseball diamonds, a pony ring, and a swimming pool. There is an outstanding zoo and a spectacular circular painting of the Battle of Atlanta called the *Cyclorama*. (Published by Witt Bros., Atlanta.)

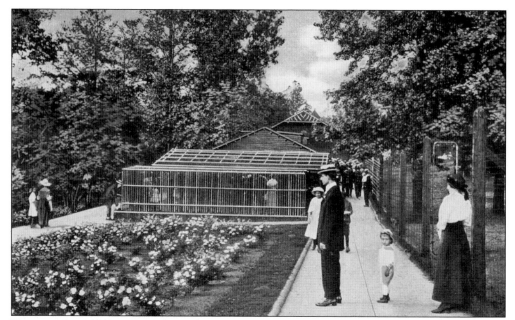

VIEW IN GRANT PARK, SHOWING SUNKEN GARDEN. The gardens and greenhouses of Grant Park once supplied all the plants and shrubs for the other parks in the city. The park is named for Col. Lemuel P. Grant, who planned the fortifications for Atlanta in 1863. Colonel Grant donated the original 100 acres to the city in 1882. (Published by I.F. Co., Atlanta.)

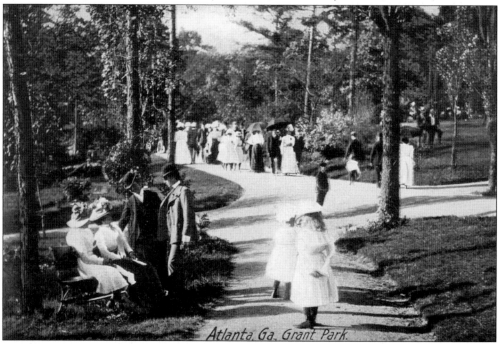

GRANT PARK. This early 1900s view of people taking leisurely walks along shaded paths illustrates one of the attractions of Grant Park. The women's and little girls' dresses are particularly indicative of the period. (Published by Hugh C. Leighton Co., Portland Maine; card sent 1907.)

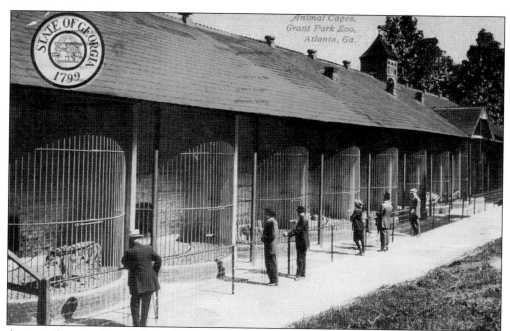

ANIMAL CAGES, GRANT PARK ZOO. The zoo began in 1889 with a gift from G.V. Gress, a wealthy merchant of Atlanta. He presented the city with the menagerie of a bankrupt circus he had bought in order to secure its heavy wagons for his lumber business. He also erected the first shelters for the animals. In early years, the collection was known as the Gress Zoo. (Published by Witt Bros., Atlanta; card sent 1913.)

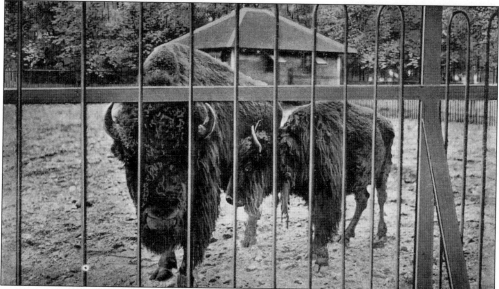

BUFFALO IN GRANT PARK. A notable addition to the zoo came in 1935, when Asa G. Candler, Jr. gave his private collection of animals to the city. Candler had assembled 84 fine species of animals and birds on his estate on Briarcliff Road; however, neighbors objected to them and taxes were heavy. He offered his menagerie to the zoo, provided that appropriate shelters were built for them; volunteer contributions of dimes from school children and other donations accomplished the task. (Published by I.F. Co., Atlanta.)

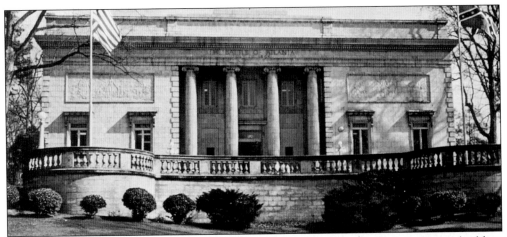

THE CYCLORAMA IN GRANT PARK. Near the center of Grant Park, this impressive building houses this legendary circular painting of the Battle of Atlanta. The front of the building is constructed of flecked terra cotta, its entrance dominated by four Ionic columns. The rear of the building is constructed in circular form to accommodate the huge canvas. The approach to the painting is by means of a tunnel that leads to a platform in the center of the circular area. The platform is positioned above the tracks of the contested Georgia Railroad, between the two opposing forces. (Published by H.S. Crocker Co., San Francisco.)

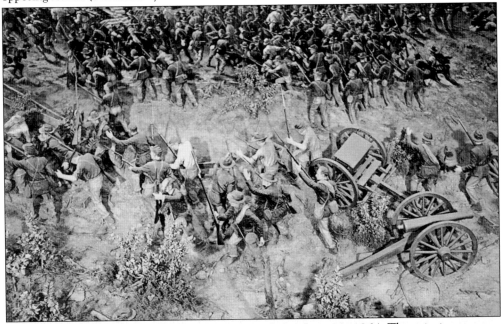

THE CYCLORAMA PAINTING OF THE BATTLE OF ATLANTA, JULY 22, 1864. The painting portrays General Sherman's Union troops, over 100,000 strong, storming the Confederate defenders of Atlanta; the moment of the painting captures a spirited Confederate counter-attack. The painting is 50 feet high, 400 feet in circumference, and is valued at over $1 million. Completed in 1887 by a corps of artists, the picture was sold and exhibited several times; George V. Gress bought it in 1893 and gave it to the city of Atlanta. The extension of the painting to include three-dimensional figures and life-like groundwork makes it unique. (Published by Scenic South Card Co., Bessemer, Alabama.)

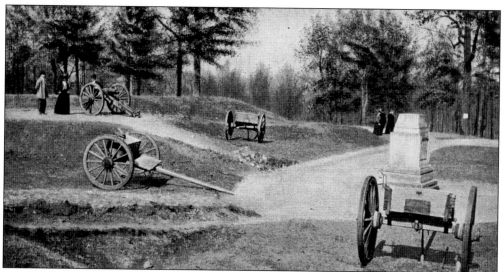

FORT WALKER, GRANT PARK. Traces of the breastworks built in 1864 for the defense of Atlanta are visible in Grant Park. Fort Walker is preserved exactly as it was during the war and is a point of historical interest to park visitors. It was named for General W.H.T. Walker, who was killed July 22, 1864. (Published by Raphael Tuck and Sons, London.)

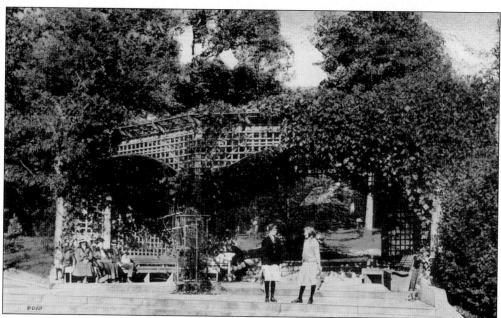

RUSTIC ARCH, WAITING GATE, GRANT PARK. Through the years, the natural advantages of the park's woods and streams have been enhanced by additions and various constructions. The Waiting Gate is one such pleasant place. (Published by the Chessler Co., Baltimore.)

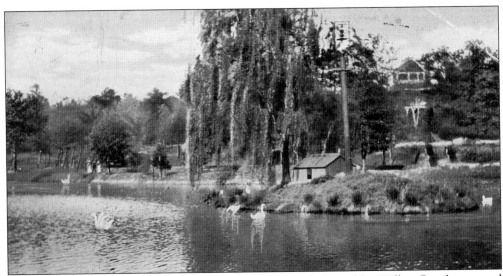

SWAN ISLAND, GRANT PARK. A natural ravine in the park formed by Willow Brook was used in 1886 for construction of a small lake that was later enlarged. Swan Island rises picturesquely from the lake on which the swans glide; it is a favorite picnic spot. (Published by Raphael Tuck and Sons, London.)

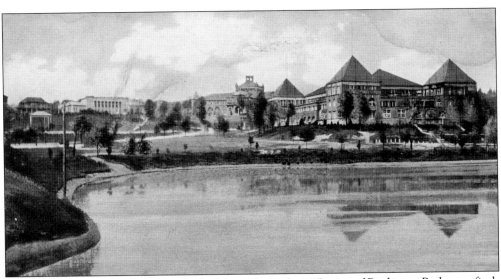

EXPOSITION GROUNDS, PIEDMONT PARK. Throughout the 185 acres of Piedmont Park, one finds a lake, many drives, shaded walks, and recreational facilities. Atlanta's largest municipal park began when the Gentlemen's Driving Club (later the Piedmont Driving Club) bought the land for the forthcoming Piedmont Exposition, which opened in October 1887. During the 12 days of the exposition, thousands of people viewed the exhibits and enjoyed entertainments and fireworks. In 1895, the Cotton States and International Exposition was held here. (Published by Raphael Tuck and Sons, London.)

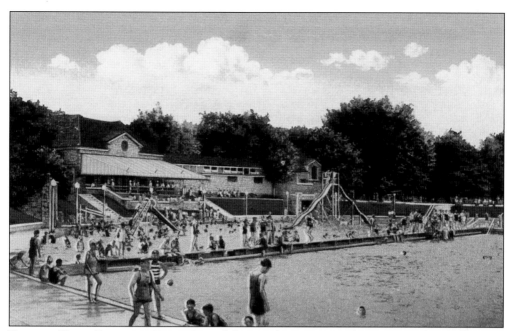

BATHING POOL, PIEDMONT PARK. One of the popular recreational areas in Piedmont Park was the swimming pool, seen here in the 1930s. Along with a golf course, tennis courts, a polo field, baseball diamonds, and a supervised playground for children, the opportunities for happy leisure were numerous. (Published by Imperial Post Card Co., Atlanta.)

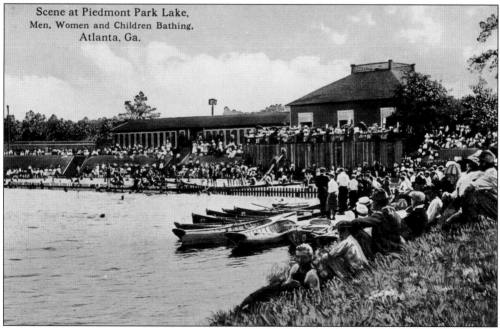

SCENE AT PIEDMONT PARK LAKE. As part of the 1894 preparation for the Cotton States Exposition, this lake was dug and several large buildings were erected. During the expo, the lake was used for aquatic events; it was the first time such sports had been seen publicly in Atlanta. (Published by I.F. Co., Atlanta.)

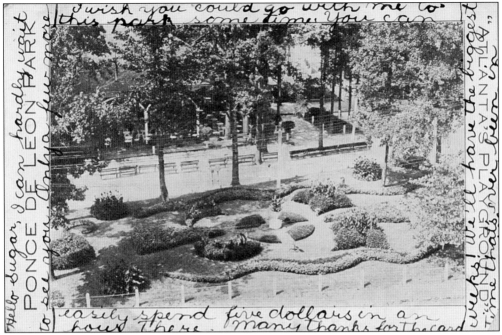

On the image margins (handwritten): *I wish you could go with me to this park some time. You can* / *Hello sugar, I can hardly write* / *PONCE DE LEON PARK* / *See you only a few more* / *"Atlanta's playground" the biggest* / *I will have the biggest I'll have* / *easily spend five dollars in an hour there. Many thanks for the card*

PONCE DE LEON PARK, ATLANTA'S PLAYGROUND. This card, somewhat marred by the necessity of writing the message around its margin, demonstrates the plight of the sender. He was not allowed to put his message on the addressee side. Ponce de Leon opened in 1906, after being a mecca since the 1870s as Ponce de Leon Springs. Offered were many new popular amusements, including a midway, a skating rink, and picnic grounds. (No publication information available; card sent 1908.)

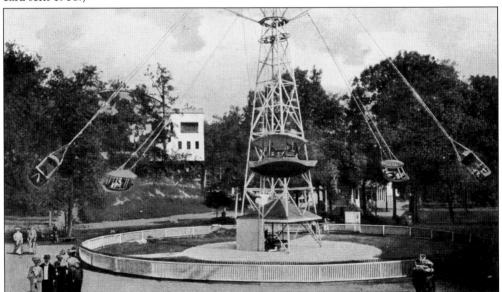

PONCE DE LEON PARK. The giant swings were a popular feature of the park in 1907. Here we see that the "swings" were really little gondolas with roofs, in which patrons could sit comfortably. Tuck calls them "revolving airships." (Published by Raphael Tuck and Sons, London; card sent 1907.)

98

Ansley Park, the finest Residence District, Atlanta, Ga.

ANSLEY PARK, THE FINEST RESIDENCE DISTRICT, ATLANTA. Originally called Peachtree Garden, Ansley Park was developed by Edwin P. Ansley, beginning in 1904 in the area along Peachtree, north of Fourteenth Street. Ansley's home at 205 Prado was later purchased for use as the governor's mansion. Many beautiful homes owned by wealthy Atlantans were built here. (Published by I.F. Co., Atlanta; card sent 1918.)

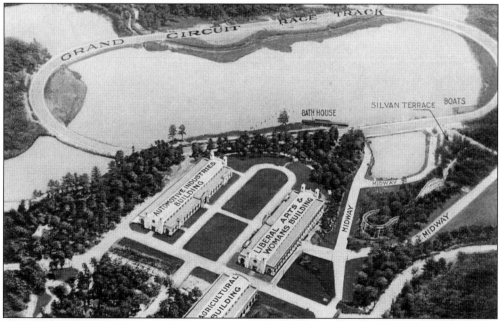

BIRD'S-EYE VIEW OF LAKEWOOD PARK SHOWING RACE TRACK. Lakewood Park was first developed for the Southeastern Fair of 1916, the first of many such fairs held here. This card conveniently labels the principal buildings and other areas. Features of the park in the 1920s were its lake and racetrack; a fourth building was added in 1948. (Published by Imperial Post Card Co., Atlanta.)

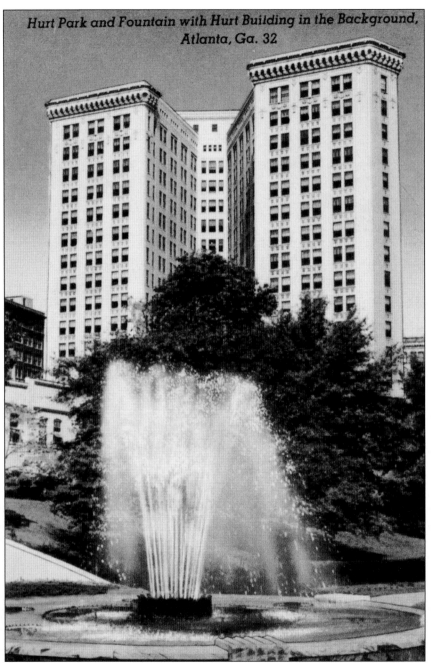

Hurt Park and Fountain with Hurt Building in the Background, Atlanta, Ga. 32

HURT PARK AND FOUNTAIN, WITH HURT BUILDING IN THE BACKGROUND. Bounded by Gilmer and Courtland Streets and Edgewood Avenue, this small triangular park in downtown Atlanta has trees, shrubs, and an illuminated fountain. Dedicated November 23, 1940, it was the first new park in the downtown area since the Civil War. It memorializes Joel Hurt, a pioneer developer of Atlanta in the 1880s and 1890s; he was president of the Trust Company of Georgia, an office building promoter, and the energizer behind the opening of Inman Park; he was the man who first brought electric streetcars to Atlanta. (Published by R and R News Co., Atlanta.)

Seven

STREETS

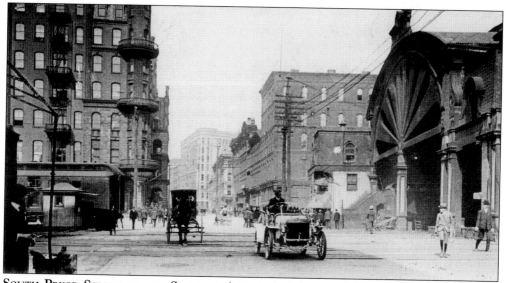

SOUTH PRYOR STREET AT THE STATION, ATLANTA. A busy and dangerous intersection, this 1903 view shows Pryor Street crossing the tracks at the Union Station. A later viaduct relieved the danger and congestion. The Kimball House is visible in the left corner. (Published by Rotograph Co., New York.)

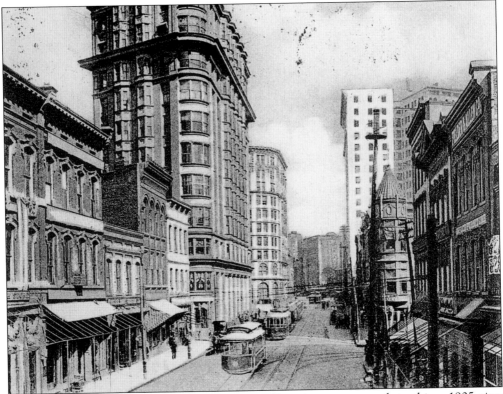

LOWER PEACHTREE STREET, ATLANTA. An unusually quiet scene prevails in this *c.* 1905 view of one of the city's busiest streets. The English-American Building overshadows the trolley cars and the horse-and-buggy transport. (Published by Witt Bros., Atlanta; card sent 1907.)

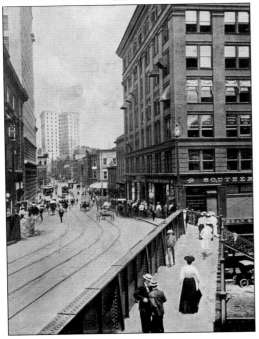

THE VIADUCT, PEACHTREE STREET. The Peachtree Street to Whitehall Street Viaduct was built in 1901. Two hundred feet long and 60 feet wide, it was built of iron and paved with asphalt. The building on the right contained the Southern Railway offices. (Published by Raphael Tuck and Sons, London; card sent 1909.)

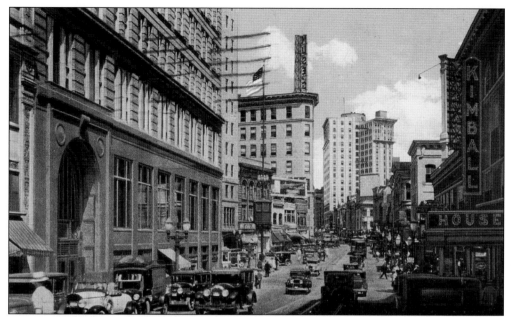

PEACHTREE STREET, LOOKING NORTH FROM VIADUCT. The automobiles date this picture, though a distant trolley can be seen. The flag positions the intersection of Five Points. Kimball House is on the right; the building in the center with the tall sign is Muse's Clothing Company. (Published by Imperial Post Card Co.; card sent 1937.)

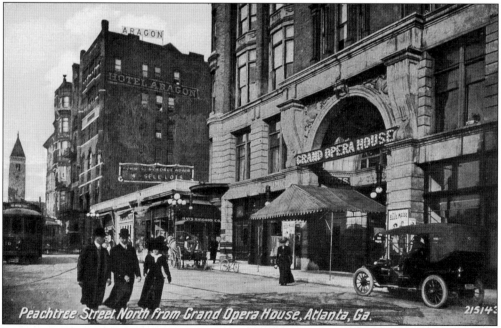

PEACHTREE STREET, LOOKING NORTH FROM GRAND OPERA HOUSE. The trolley and the horse-drawn buggy contrast with the automobile in this *c.* 1907 picture. The Grand Opera House was Atlanta's theatrical center for decades. One notes its proximity to the Aragon Hotel, where many theatrical stars stayed when they were booked in Atlanta. In the distance is the First Baptist Church. (Published by Leighton and Valentine Co., New York.)

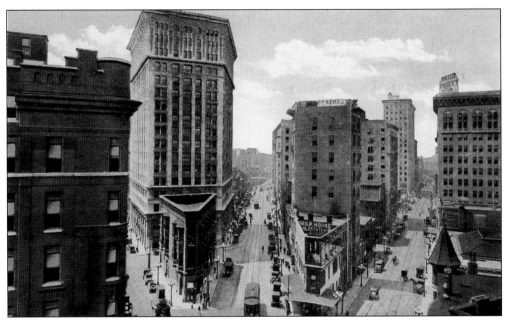

JUNCTION OF FORSYTH, PEACHTREE, AND PRYOR STREETS. There are several such junctions in Atlanta, resulting in seemingly triangular or near-triangular buildings. Dominant in this view is the Candler Building (left center) with the smaller triangle in front of it. The Hotel Ansley is on the right. (Published by the I.F. Co., Atlanta.)

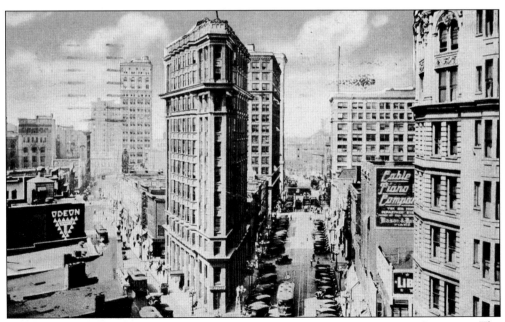

BROAD AND PEACHTREE STREETS SHOWING HEART OF ATLANTA AND FLATIRON BUILDING. The busy city traffic of the 1920s is evident here, with several prominent commercial signs seen on the buildings. The big building (far right) is the Piedmont Hotel. (Published by Brown and Allen, Atlanta; card sent 1921.)

PEACHTREE STREET, SHOWING FOURTH NATIONAL BANK. Standing like a lone sentinel at Five Points in 1908, the Fourth National Bank overlooks muddy streets, streetcars, and street banners relating to a YMCA Building Campaign and William Jennings Bryan, who ran a third time for president that year. (Published by Leighton and Valentine Co., New York.)

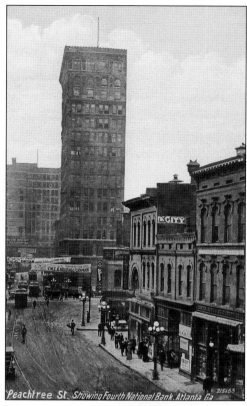

Peachtree St., Showing Fourth National Bank, Atlanta, Ga.

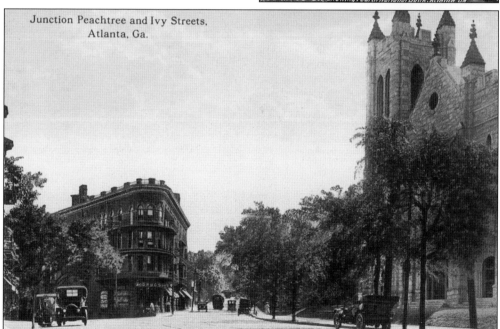

Junction Peachtree and Ivy Streets. Atlanta, Ga.

JUNCTION OF PEACHTREE AND IVY STREETS. Another triangular junction shows a drugstore on the left. The church on the right is the First Methodist, actually located on Porter Place. (Published by I.F. Co., Atlanta; card sent 1912.)

PEACHTREE STREET. The quiet residential atmosphere given here illustrates the ambience of north Peachtree in the early part of the century. Horse-drawn transport was typical in 1907. (Published by Raphael Tuck and Sons, London.)

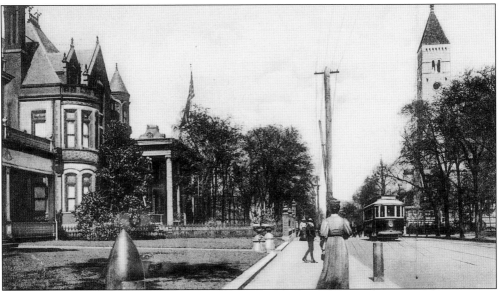

PEACHTREE STREET. Peachtree Street, between Ellis and Cain Streets, still had elaborate Victorian houses with lawns and fences in 1907. On the left is the ornate Richards (or Abbott) house, and beyond it is the Leyden House. Farther down, at Cain Street, was the old governor's mansion, which was located across from the First Baptist Church. This block was later occupied by Davison's department store and the Henry Grady Hotel. (Published by Witt Bros., Atlanta.)

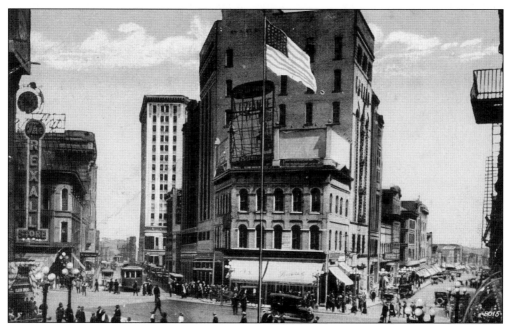

VIEW AT FIVE POINTS, LOOKING EAST. The busy hub of downtown Atlanta is replete with both pedestrians and vehicles in the 1920s. Many commercial signs have appeared; the globe streetlights mark the era. (Published by the Chessler Co., Baltimore; card sent 1924.)

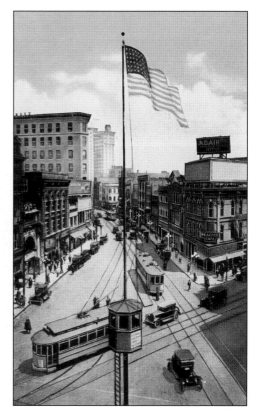

FIVE POINTS, ATLANTA. The Atlanta Convention Bureau informs us on this card that "Five Points is the radiating center of the Southeast . . . where more traffic to the square inch moves in safety than in any other city in the world." The police officer, seen in his elevated traffic control station, was undoubtedly kept busy. (Published by Imperial Post Card Co., Atlanta.)

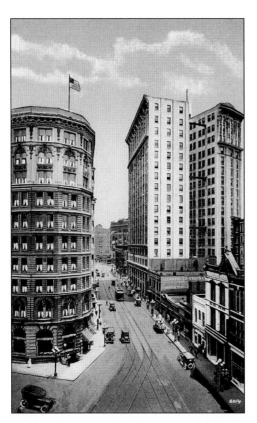

PEACHTREE STREET, LOOKING NORTH SHOWING PIEDMONT HOTEL AND CANDLER BUILDING. The Piedmont at the corner of Luckie and Peachtree, and its neighbor, the "skyscraper" Candler Building, dominate the downtown street. Someone has taken the trouble to align all the curtains in the hotel windows; perhaps it was a retouch artist. (Published by the Chessler Co., Baltimore.)

PEACHTREE STREET AT PIEDMONT HOTEL CORNER. A brief comment by the maker or owner of this card writes, "Piedmont Hotel—Headquarters of Toledo Shriners." This explains the festive look of festooned flags on the hotel. The automobiles at right and in the street suggest that this view is from the 1920s. (No publishing information available; real photo postcard.)

PEACHTREE STREET, LOOKING NORTH FROM MARIETTA STREET. A much longer view shows old Peachtree looking north from Five Points. The Candler is seen at right, with the Piedmont across from it. The Flatiron Building is in the center. (Published by Tenenbaum Bros., Atlanta.)

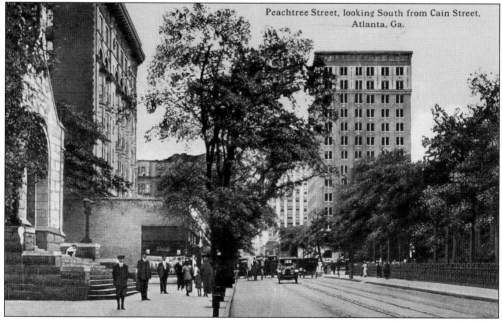

PEACHTREE STREET LOOKING SOUTH FROM CAIN STREET. Pictured in this view is the First Baptist Church entrance (left); across the street behind the trees are Victorian homes, including the governor's mansion. Within two blocks, one would be downtown. Four pedestrians are very aware of the cameraman. (Published by I.F. Co., Atlanta; card sent 1915.)

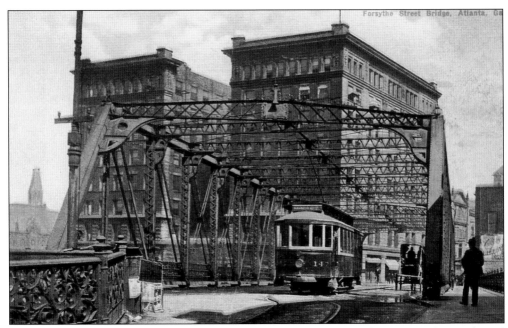

FORSYTH STREET BRIDGE, ATLANTA. This view looks north from the corner of Forsyth and Alabama Streets. The bridge across the tracks was built in 1891. The Austell building dominates the background. (Published by Georgia News Co., Atlanta.)

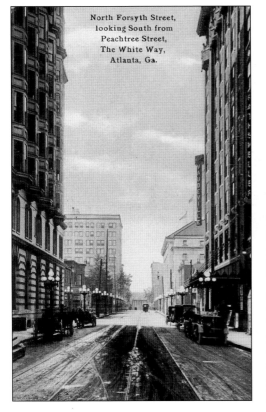

NORTH FORSYTH STREET, LOOKING SOUTH FROM PEACHTREE STREET. Pictured on the right in this view is the Hotel Ansley's Rathskeller. A corner sign reads "Keith Vaudeville." The automobiles on the right contrast with the horse-drawn vehicles on the left. The sender of the card writes, "Tell Wilburn to go to Douglasville Sat. morning. I am going up thier on the train to have some teath filed and want to cum back with him." The card was mailed to Powder Springs. (Published by I.F.P. Co., Atlanta; card sent 1911.)

CAPITOL AVENUE. A peaceful vista near the Capitol Building shows two famous churches previously identified. The areas along Capitol Avenue and to the east were developed in the 1890s. Much of it had been devastated during the Civil War. (Published by Witt Bros., Atlanta.)

GEORGIA CAPITOL SQUARE. Once again, we are viewing the Second Baptist Church at the corner of Washington and Mitchell Streets, within a block of the Capitol Building. (Published by Curt Teich Co., Chicago.)

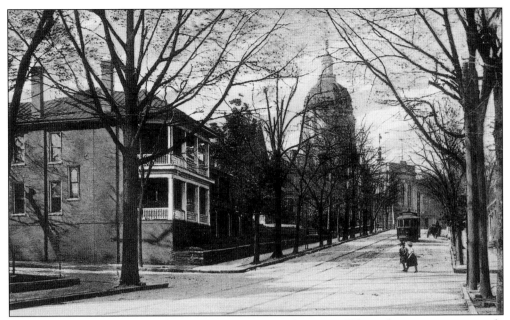

CAPITOL AVENUE, LOOKING NORTH SHOWING THE CAPITOL. When this picture was made c. 1910, this neighborhood was primarily residential. Very little traffic disturbed the scene. (Published by the Georgia News Co., Atlanta.)

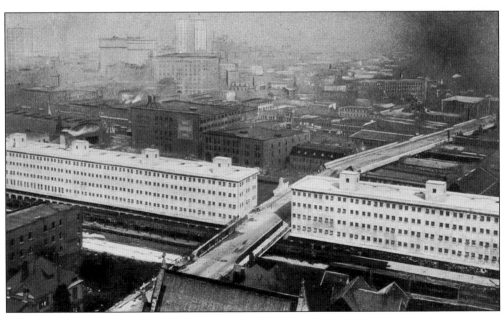

THE NEW WASHINGTON STREET VIADUCT PASSING THROUGH NEW L&N AND N.R.R. TERMINALS. A smoky Atlanta is seen here in the 1920s with the central business district in the center background. The gray, rounded roof of the railway car shed is seen at center left. (Published by S.H. Kress.)

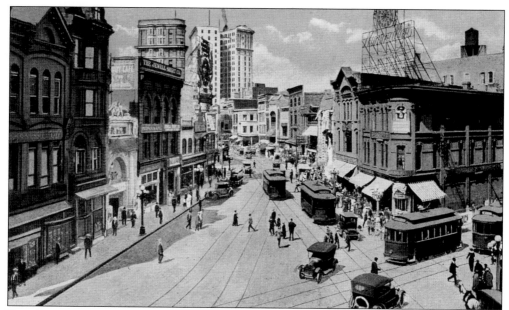

FIVE POINTS. A wedge-shaped area, Five Points is located at the intersection of Peachtree, Decatur, and Marietta Streets and Edgewood Avenue. Principal thoroughfares radiate from this spot to all parts of the metropolitan area. Because of the complexities of the buildings and the photographic angles, there are hundreds of pictures of Five Points as it changed through the years. Vehicular traffic dates this view to the 1920s. (Published by the Imperial Post Card Co., Atlanta.)

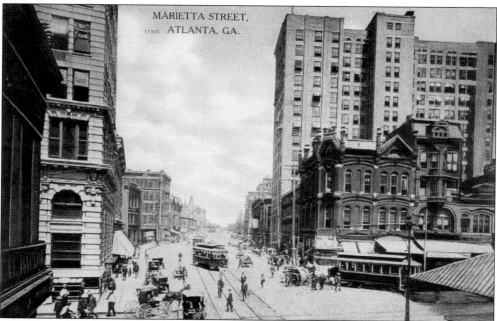

MARIETTA STREET. One of the thoroughfares emanating from Five Points, this 1908 view of Marietta Street shows modern architecture making its appearance amid the Victorian. Few automobiles are present, and pedestrians take their time in crossing the street. (No publication information available; card sent 1908.)

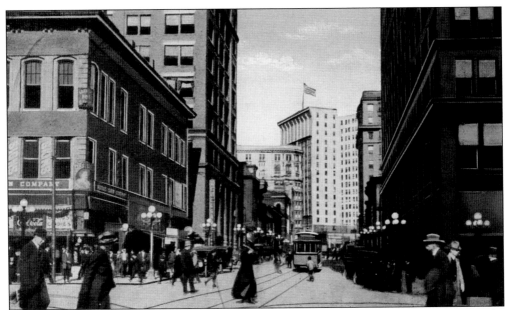

BROAD STREET, LOOKING NORTH FROM MARIETTA. Just a block away from Five Points is the intersection with Peachtree Street. There are many automobiles, and women's dress indicates the time as being c. 1915. (No publishing information available.)

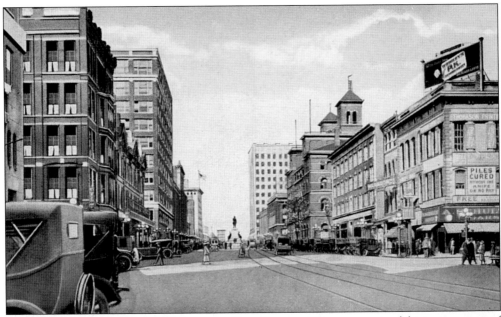

MARIETTA STREET, LOOKING WEST FROM FIVE POINTS. There are several historic points of reference in this picture. The old U.S. post office / city hall is seen at right center; the Henry Grady statue stands silhouetted against the sky at center, and the automobiles are indicative of the 1920s. Women's dresses are noticeably shorter. An interesting advertisement on the building on the right reads, "Piles Cured without the Knife or No Pay." (Published by Imperial Post Card Co., Atlanta.)

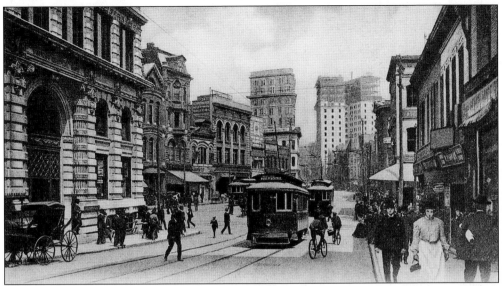

WHITEHALL AND MARIETTA STREETS. In the immediate Five Points area is the Fourth National Bank (left), and construction is under way on the Candler Building's double edifice (right center). The date is probably 1905. (No publishing information available.)

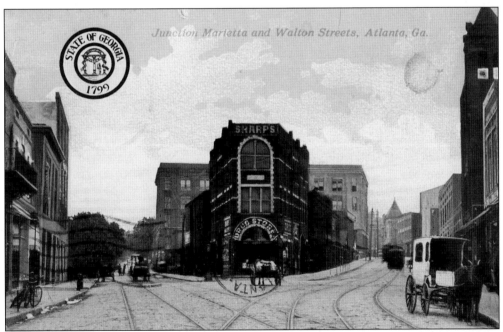

JUNCTION OF MARIETTA AND WALTON STREETS. About seven blocks northwest of Five Points, Walton Street disappears into Marietta Street at this triangular junction. An early view of a seemingly quiet neighborhood shows Sharp's Drugstore in the apex of the triangle, with a delivery wagon on the right and typical vehicular transport. (Published by Witt Bros., Atlanta; card sent 1918.)

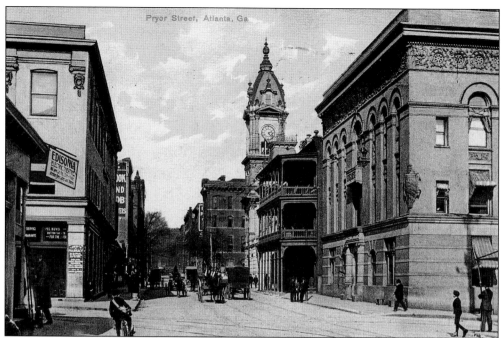

PRYOR STREET. This view from Pryor and Mitchell Streets looks north to Hunter, where the old courthouse, seen here, was located until 1911, when it was demolished. The building on the right is the Southern Bell Building. A most interesting sign can be seen at left for Edisonia Electric Theatre. The movies were in their infancy. (Published by Georgia News Co., Atlanta; card sent 1909.)

PEACHTREE STREET, 1887. Having built back most of the buildings destroyed in the War, Peachtree Street was going about its business in 1887. Looking north from the railroad tracks is the National Hotel on the left, a restaurant on the right, carriages and pedestrians throughout, and the steeple of the old First Methodist Church in the distance. (Published by American Post Card Co., New York; card sent 1907.)

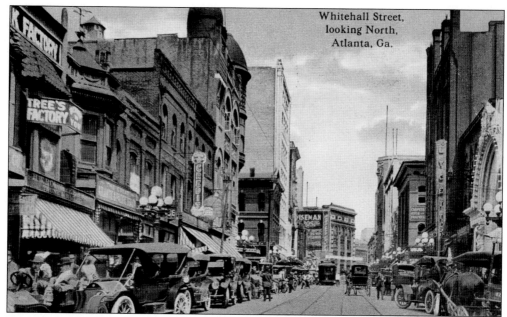

WHITEHALL STREET, LOOKING NORTH. This picture was probably taken from Mitchell Street, looking north toward Five Points. The first two buildings on the left are Tree's Factory and the Great Atlantic and Pacific Tea Company. On the right is the marquee of a theater, Lycett's, then the corner of a building displaying a sign for "Carpets, Rugs, and Drapery." Early automobiles are crowded at the curb. (Published by I.F. Co., Atlanta; card sent 1919.)

WHITEHALL STREET, LOOKING NORTH. Moving one block north to the intersection of Whitehall and Hunter is a building on the right with an advertisement for "Carpets, Rugs, and Drapery." The white building on the left is undergoing renovation. In the distant center, the Eiseman Bros. building stands significantly. The sign includes "Clothing, Shoes, Furnishings, Hats" from the readable portion. Cars come in many models, and pedestrians are numerous. The time is *c.* 1920. (Published by Imperial Fruit Co., Atlanta.)

117

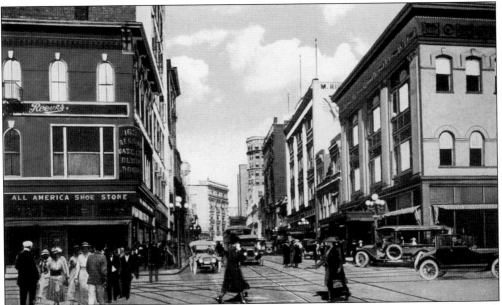

WHITEHALL STREET, LOOKING TOWARD VIADUCT FROM HUNTER STREET. Once again we look north from Hunter. The "Carpets" sign is missing from this 1920s view. Eiseman's is in the distance, the Century Building peeks out at right center, and on the left corner is an "All American Shoe Store." (Published by Imperial Post Card Co., Atlanta.)

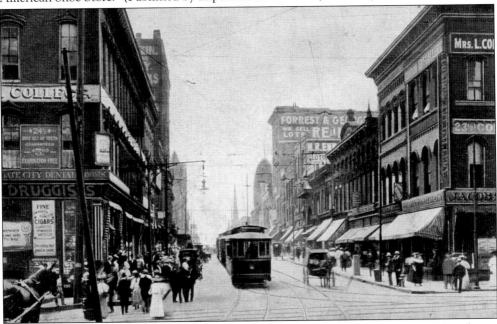

WHITEHALL STREET. This scene at Five Points, where Whitehall integrates into Peachtree, shows an early view of this complex and busy area. Jacobs Pharmacy, seen on the right, was located at Peachtree and Marietta in 1884. Joseph Jacobs, an apprentice of Dr. Crawford Long, set up 16 retail drugstores before his death in 1929; he pioneered the "cut-rate" pricing of items necessitating the use of pennies: 19¢, 29¢, 69¢, etc. (Published by International Post Card Co., New York; card sent 1907.)

Eight

POTPOURRI

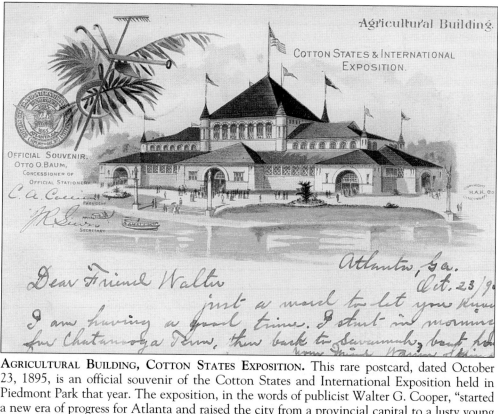

AGRICULTURAL BUILDING, COTTON STATES EXPOSITION. This rare postcard, dated October 23, 1895, is an official souvenir of the Cotton States and International Exposition held in Piedmont Park that year. The exposition, in the words of publicist Walter G. Cooper, "started a new era of progress for Atlanta and raised the city from a provincial capital to a lusty young metropolis." Financed by the city, the county, and business men, it cost nearly $3 million; it had 6,000 exhibits, admitted 800,000 visitors, and received world-wide publicity. The park was transformed into a veritable fairyland with incandescent light; the Midway contained a variety of entertainments, from "coochee-coochee" dancers to "living pictures," the earliest movies, which were a flop. (Published by H.A.K. Co., Cincinnati; card sent 1895.)

BURNS COTTAGE. On January 25, 1896, Dr. Joseph Jacobs invited a group of Atlantans to organize the Robert Burns Club; it was the 137th anniversary of the poet's birth. There were annual meetings thereafter, and in 1911, the club opened its own clubhouse, an exact replica of the poet's cottage at Alloway near Ayr, Scotland. It is located in a park at 988 Alloway Place SE, off East Confederate Avenue. (Published by Witt Bros., Atlanta; card sent 1911.)

OLD COTTON MILL DESTROYED BY SHERMAN IN 1864. There are still a few reminders around Atlanta of Sherman's famous march. This windowless remnant of a cotton mill is one such historic marker in Douglas County. (No publication information available; card sent 1906.)

SCHOOL BOOKS BOUGHT. An advertising postcard typical of the 1920s shows what would normally be the address side. We learn all we need to know about the Southern Book Concern. (No publishing information available.)

FRANK E. BLOCK COMPANY, MANUFACTURERS OF CONFECTIONERY AND CRACKERS. A card of receipt from the business to the customer, this one indicates $13.23 received; these cards have been used by businesses for many decades. (No publishing information available; card sent 1911.)

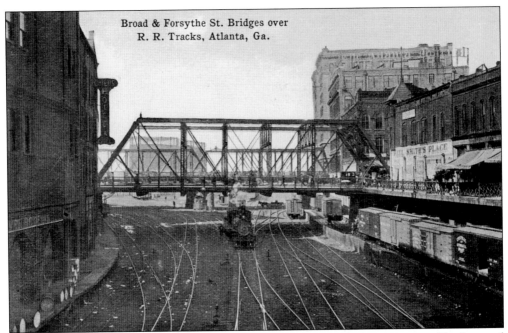

Broad & Forsythe St. Bridges over
R. R. Tracks, Atlanta, Ga.

BROAD AND FORSYTH ST. BRIDGES OVER RAILROAD TRACKS. The importance of bridges and viaducts over Atlanta's railroad tracks escalated through the years. The Forsyth Street bridge was built in 1891. The sign on the left localizes Child's Hotel; it was about as close to the railroad as one could get. (Published by Imperial Fruit Co., Atlanta.)

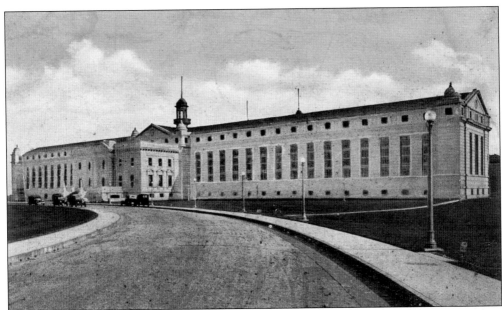

FEDERAL PRISON, ATLANTA. The Federal Penitentiary opened in Atlanta on January 31, 1902, on a 300-acre tract on McDonough Boulevard. It is the largest of the government's 30 penal institutions, now housing more than 3,000 inmates. The east and west wings were added in 1915 and 1918, and were constructed of Stone Mountain granite cut by prison laborers. (Published by Imperial Post Card Co., Atlanta; card sent 1935.)

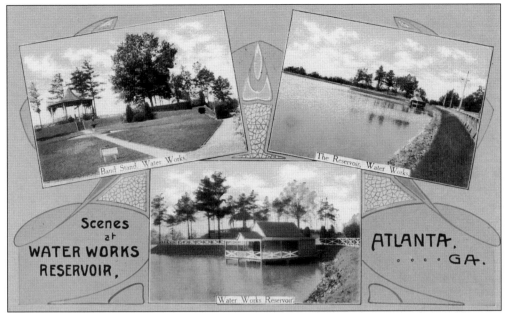

SCENES AT WATER WORKS RESERVOIR. In the vicinity of Marietta Road and Hemphill Avenue, the Atlanta Waterworks and Reservoir were constructed in 1892. The area was designed with a summer pavilion and a number of acres to be used as a park. It succeeded the 1875 waterworks that were outgrown in a decade. (Published by I.F. Co., Atlanta.)

READY FOR A CANTER OVER MOUNTAIN TRAILS AT CAMP DIXIE FOR GIRLS. On the reverse side of this card is the following text: "After school closes . . . what? In city, languidness—lassitude; in camp, happiness—health. Spend your vacation at Camp Dixie for Girls, Blue Ridge Mountains. Winter address: 414 Rhodes Building, Atlanta, Ga." (Published by Artvue Post Card Co., New York; card sent 1930.)

Piedmont Driving Club
Atlanta

A Subscription Dinner Dance

Will be given at the Piedmont Driving Club, Saturday evening, November 26.

Members are requested to notify the Superintendent not later than Friday, November 25, how many seats they wish reserved for the dinner, which will be served promptly at 8 o'clock.

GUSTAVE KUHN
Superintendent

NOTICE: Members giving dinners, parties or other functions are requested to notify the Club at least one day in advance, as the Club cannot keep on hand a very large variety of the season's offerings

PIEDMONT DRIVING CLUB. This special postcard invitation was sent to a lieutenant at Fort McPherson, evidently a member of this important Atlanta social club. Organized in 1887 as the Gentlemen's Driving Club, the club has hosted many elite gatherings through the years, including balls, dinners, and receptions, for important visitors to Atlanta. Its present building is located at 1215 Piedmont Avenue NE. (No publication information available; card sent 1910.)

HEADQUARTERS GOVERNOR'S HORSE GUARD.

ATLANTA, GA., April 25, 1895.

You are hereby commanded to appear at the office of John J. Woodside, No. 50 N. Broad street, Saturday, April 27th, at 3:30 P. M. to attend the funeral services of the late MRS. COL. JOHN MILLEDGE. Dismounted. Cap, Dress Coat and Pants, Shoes, Belt, Sabre and Yellow Gloves.
Fine for absence, $3.00.

By order of

J. S. DOZIER,
Captain Commanding.

JOHN J. WOODSIDE,
1st Sergeant.

HEADQUARTERS GOVERNOR'S HORSE GUARD. This funeral summons is a command rather than an invitation. The Governor's Horse Guard was a uniformed equestrian group that participated in many parades and celebrations from the 1880s through the early 1900s. (No publication information available; card sent 1895.)

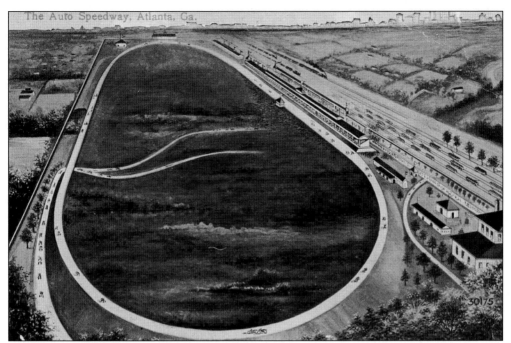

THE AUTO SPEEDWAY, ATLANTA. In 1909, Asa Candler, wealthy from his Coca-Cola earnings, purchased 300 acres near Hapeville, where he built the Atlanta Speedway. The growing automobile industry was evidenced by a huge automobile show that autumn in the city auditorium; featured were exhibits by Cadillac, Oldsmobile, Packard, Hudson, and many more. Concurrently with the show, racing events were held at the Speedway, where famous racers like Arthur Chevrolet and Barney Oldfield set new speed records. (No publishing information.)

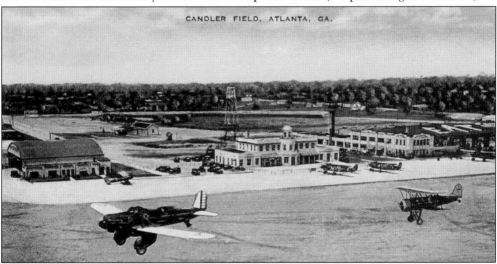

CANDLER FIELD, ATLANTA. In November 1911, Georgia's first air meet was held on the Candler Speedway property in Hapeville, which became the nucleus of Atlanta's Hartsfield International Airport. The city purchased the property in 1929, and in 1930, Eastern Airlines began regular passenger service between New York and Atlanta. By the mid-1930s, when this postcard was printed, "twenty-six passenger and mail planes arrive and depart daily from Candler Field." (Published by R and R News Co., Atlanta.)

125

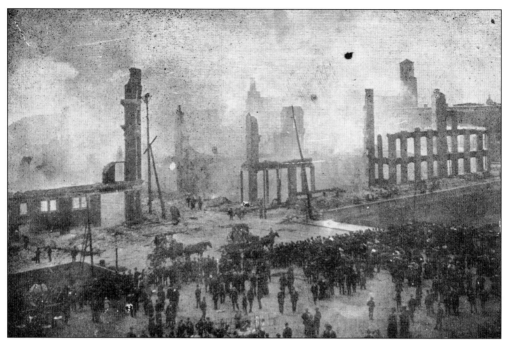

SOUVENIR OF ATLANTA'S BIG FIRE. One of Atlanta's worst fires happened on May 8, 1908, when a square block across from the Terminal Station was obliterated. Thirty-one buildings in the block bounded by Madison (Spring), Mitchell, Nelson, and South Forsyth Streets were consumed by flames. Forty-two firms were lost; the money loss was estimated at $1,250,000. (No publication information available; card sent 1908.)

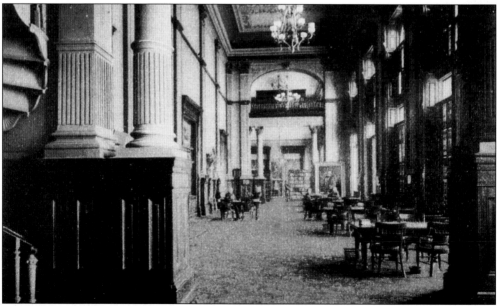

STATE LIBRARY, ATLANTA. On the second floor of the State Capitol, this lovely room extended across the Hunter Street facade. The high ceilings, Corinthian columns, balustrade, paintings, and louvered shutters gave the room a Victorian air seldom found elsewhere. (No publishing information available; card sent 1906.)

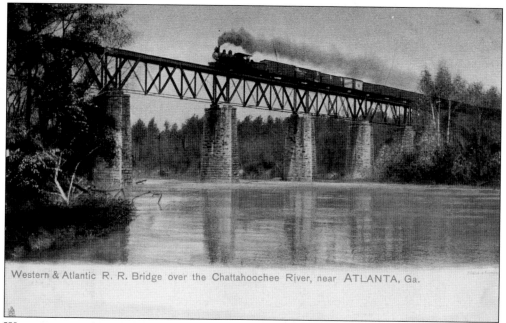

Western & Atlantic R. R. Bridge over the Chattahoochee River, near ATLANTA, Ga.

WESTERN AND ATLANTIC RAILROAD BRIDGE, OVER THE CHATTAHOOCHEE NEAR ATLANTA, GEORGIA. Chartered in the 1850s, this railroad bridge across the Chattahoochee River is located 8 miles west of the city. It cost the state nearly $7 million. Western and Atlantic is a main line between the Ohio valley and the South Atlantic coast. It was one of Sherman's objectives in his 1864 campaign. (Published by Raphael Tuck and Sons, London.)

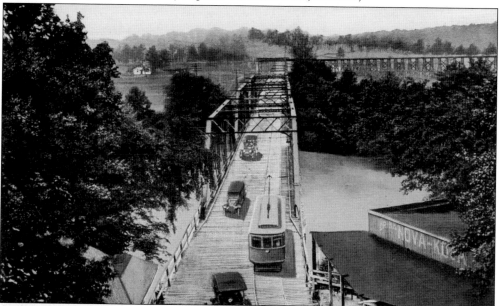

CHATTAHOOCHEE RIVER BRIDGE ON STREETCAR LANE, ATLANTA–MARIETTA, GEORGIA. Wagon-road travel between the southwestern part of Fulton County and Cobb County was much easier after the new Garrett Bridge opened on May 30, 1891. The iron structure cost $15,000. The postcard picture reflects the automobiles and streetcars of the 1920s. (Published by I.F. Co., Atlanta.)

BIBLIOGRAPHY

Atlanta: A City of the Modern South. Writers Program of the WPA in the State of Georgia. American Guide Series. Board of Education, City of Atlanta, 1942. Reprinted 1976.

Boylston, Elise Reid. *Atlanta: Its Lore, Legends, and Laughter*. Doraville, GA: Foote and Davies, 1968.

Buffington, Perry, and Kim Underwood. *Archival Atlanta*. Atlanta: Peachtree Publishers, 1996.

Cawley, Helen, and Karen Wantuck. *The Insider's Guide to Atlanta*. Manteo, NC: The Insiders Publishing, Inc., 1998.

Editors of Civil War Times Illustrated. *The Campaign for Atlanta*. Gettysburg, PA: Historical Times, Inc., 1964.

First National Bank of Atlanta. *Atlanta Resurgens*. Published by the First National Bank, 1971.

Garrett, Franklin M. *Atlanta and Environs: A Chronicle of Its People and Events*. 2 vols. Athens: University of Georgia Press, 1954.

_____. *Yesterday's Atlanta*. Seemann's Historic Cities Series No. 8. Miami FL: E.A. Seemann Publishing, Inc., 1974.

The Gate City: Atlanta. Neenah, Wisconsin: Art Publishing Co., 1890.

Georgia: A Guide to Its Towns and Countryside. Georgia Writer's Program, revised by George G.
 Leckie, 1940. Reprinted 1954.

Hornady, John R. *Atlanta, Yesterday, Today, and Tomorrow*. American Cities Book Company, 1922.

Lockerman, Doris, and Patricia La Hatte. *Discover Atlanta*. New York: Simon and Schuster, 1969.

McCall, John Clark. *Atlanta Fox Album: Mecca at Peachtree Street*. Atlanta: Fotoprint Company, 1975.

McCullar, Bernice. *This is Your Georgia*. Montgomery, AL: Viewpoint Publications, 1972.

McMath, Robert C., editor. *A Southern Pilgrimage: Central Congregational Church of Atlanta, Georgia, 1882–1982*. Atlanta: R and R Printing, 1982.

Sawyer, Elizabeth M., and Jane Foster Matthews. *The Old in New Atlanta*. Atlanta: JEMS Publications, 1976.

Shavin, Norman. *Days in the Life of Atlanta*. Atlanta: Capricorn Corporation, 1987.

Siddons, Anne Rivers. *Go Straight on Peachtree*. Garden City, N.Y.: Doubleday, 1978.